Articulated Artwork
Vol. 1

Jeremy Guerin

Copyright © 2019 Jeremy Guerin

All rights reserved.

ISBN: 9781090298737
ISBN-13:

DEDICATION

This book is dedicated to my awesome wife Shannon and my kids Conor and Emmie. They allow me to be a big kid and a geek and none of this would be possible without them.

ACKNOWLEDGMENTS

Thank you so much to my wife Shannon who puts up with my geekiness and my crazy toy obsession. And my kids help by just being kids and loving the same stuff their dad does. I also want to thank all of my Instagram followers, particularly the great friends I've made on there in the last year plus. They've shown me tremendous kindness and appreciation for my work. There's been great support from day one.

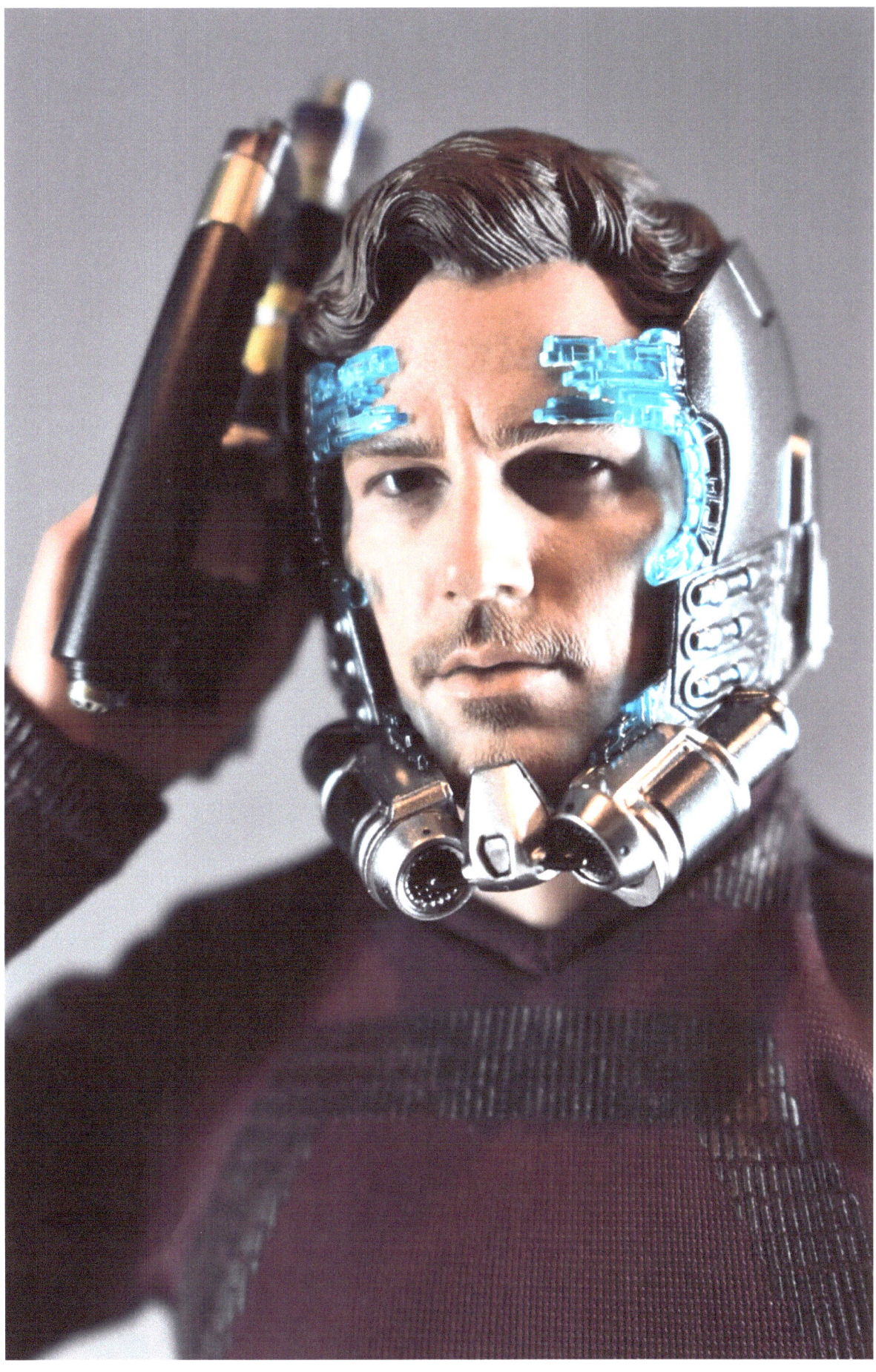

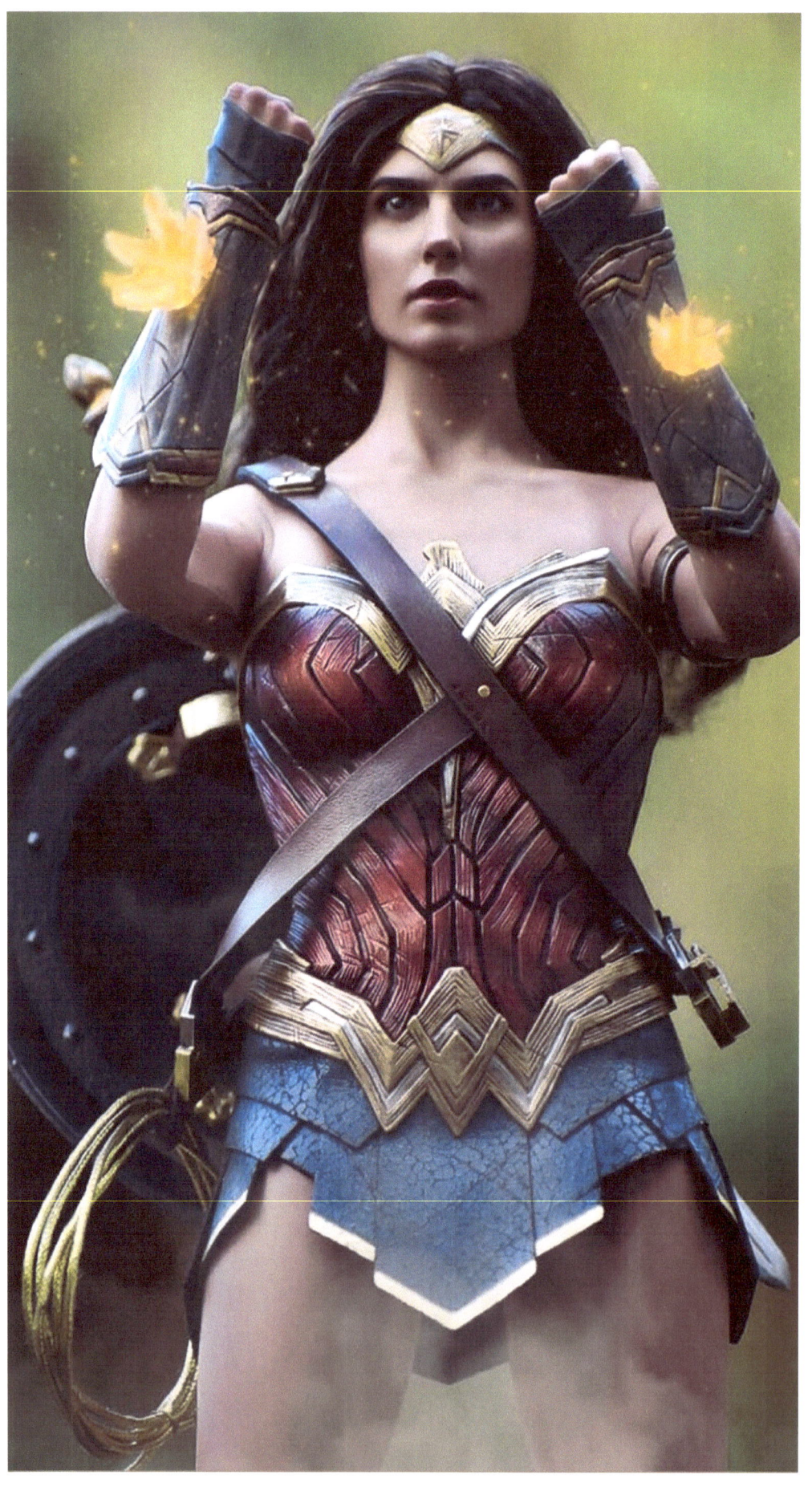

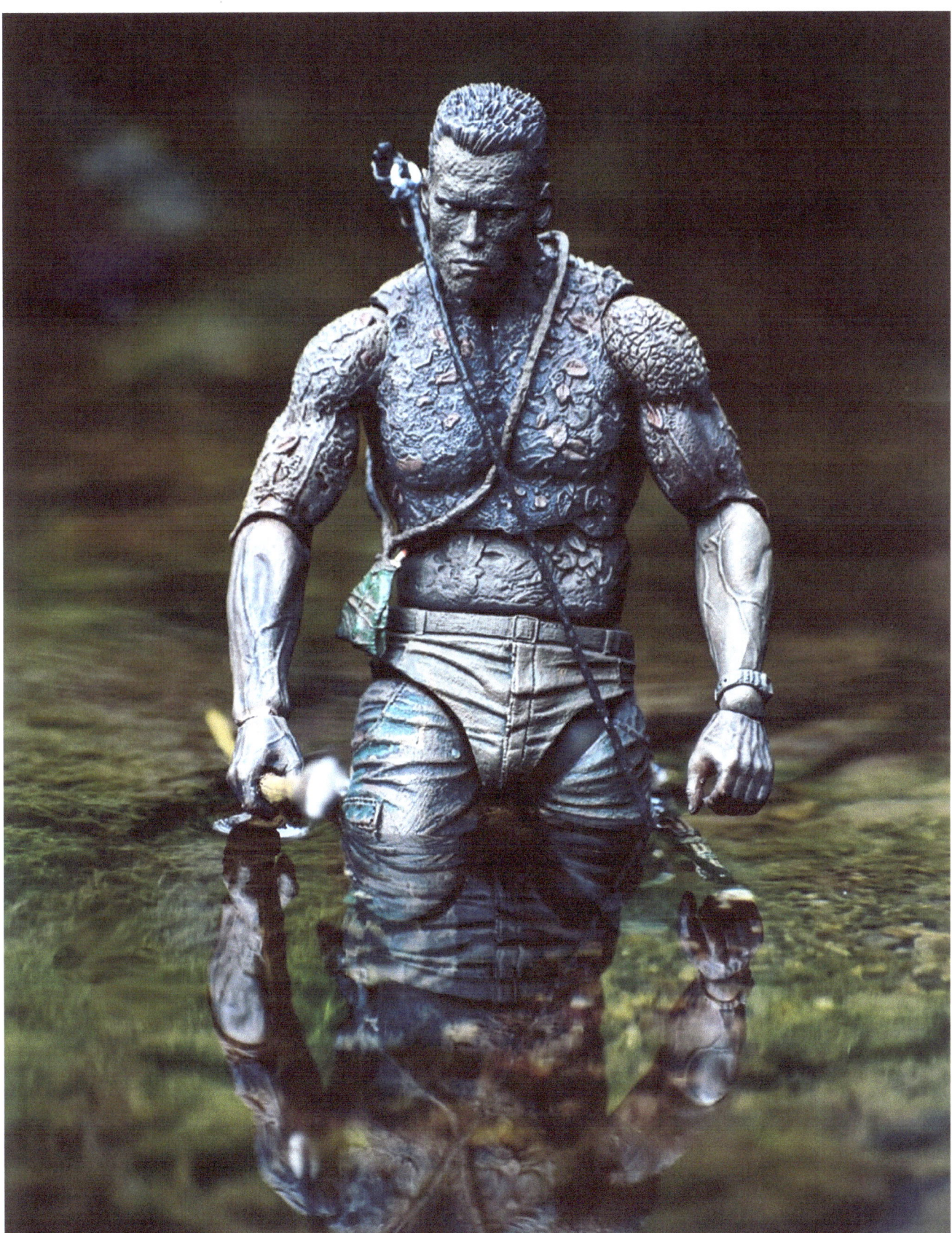

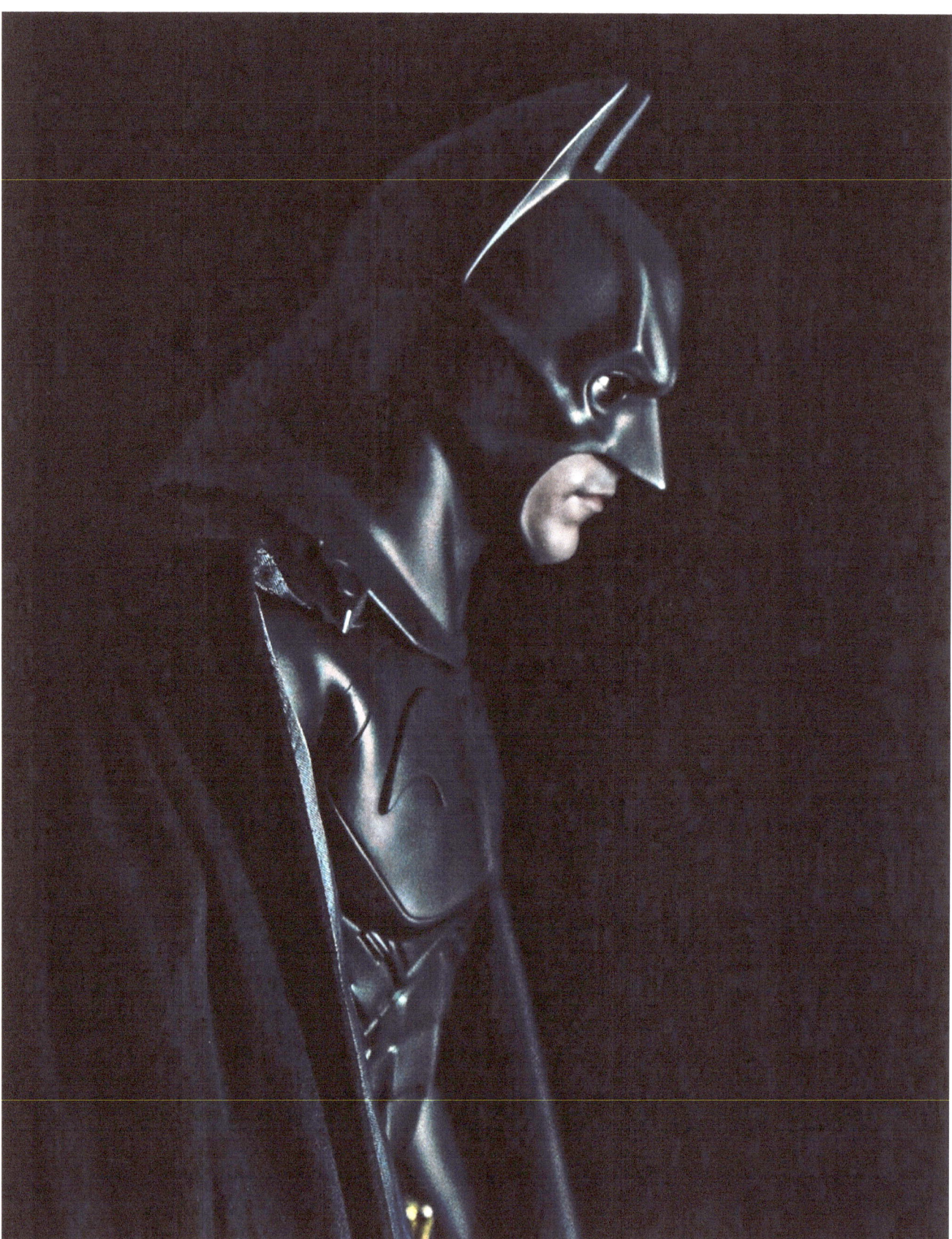

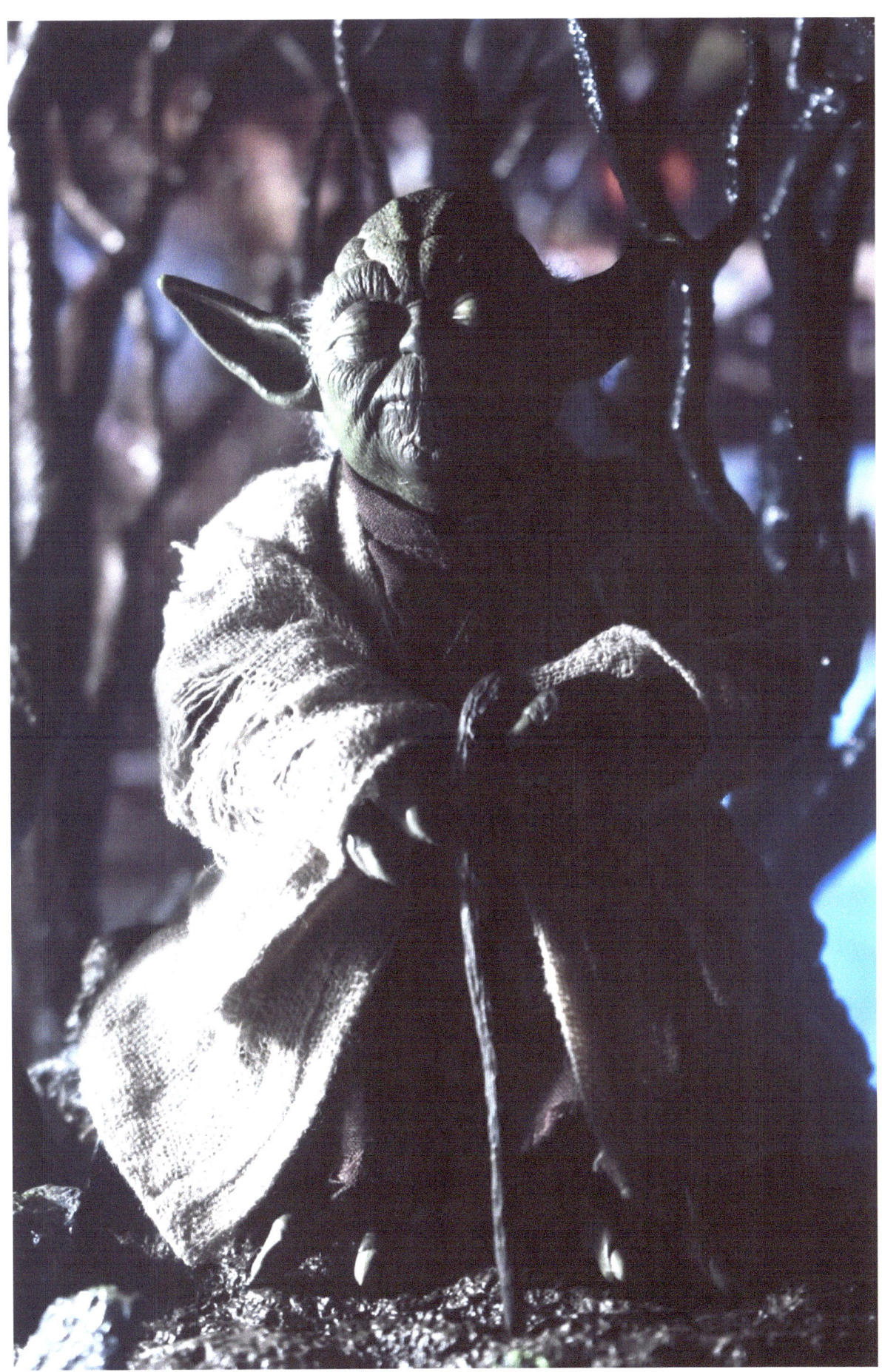

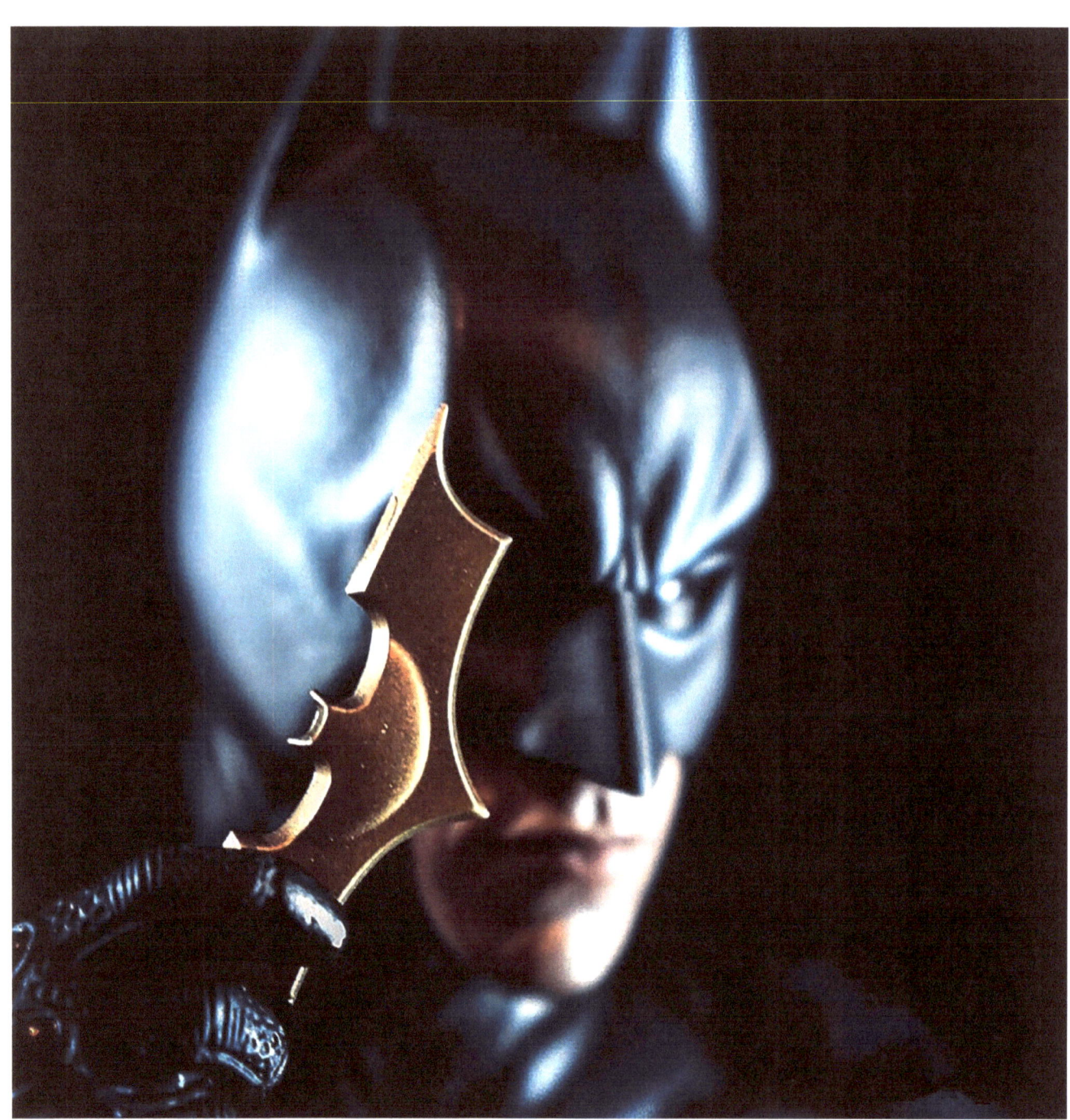

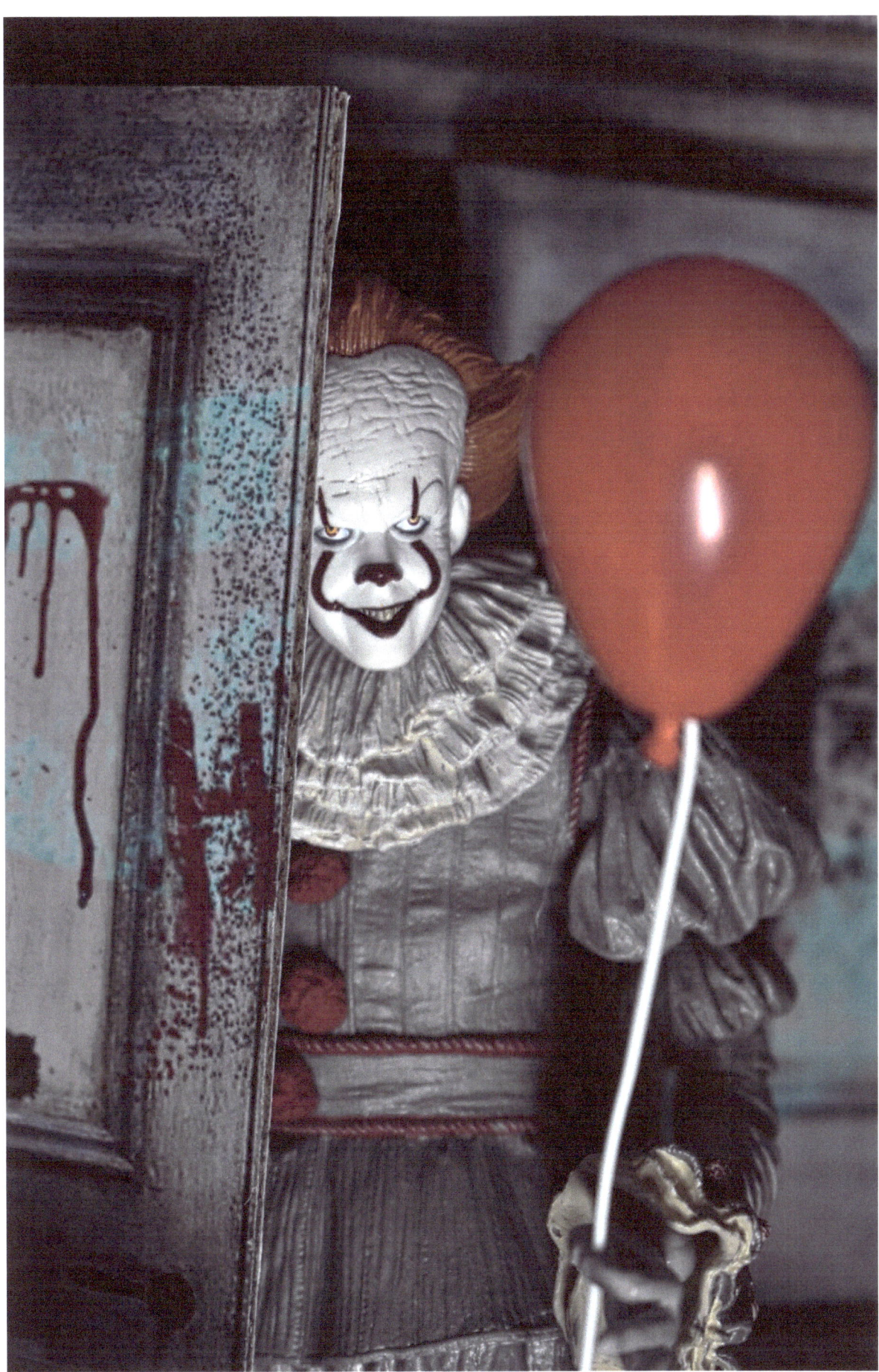

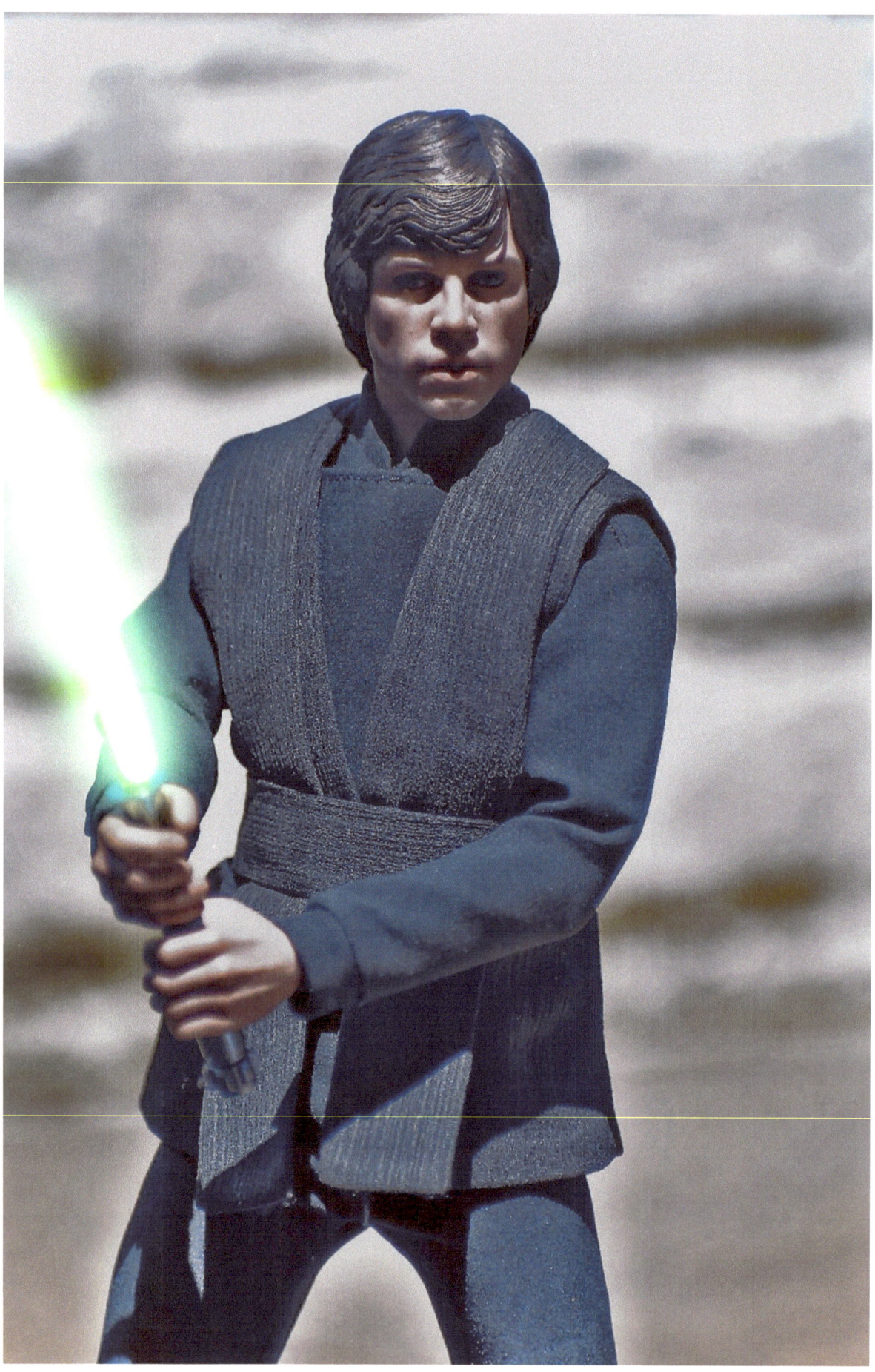

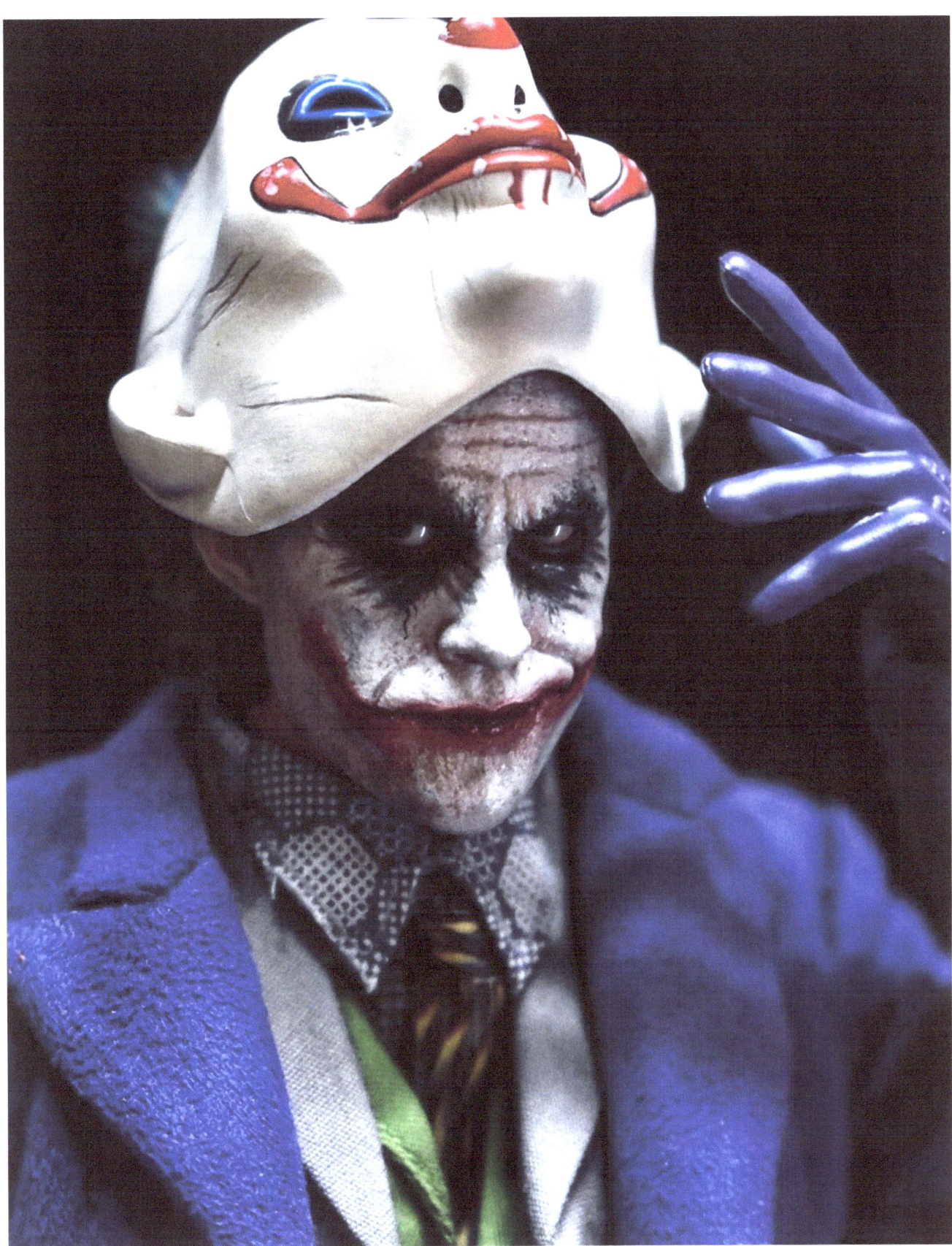

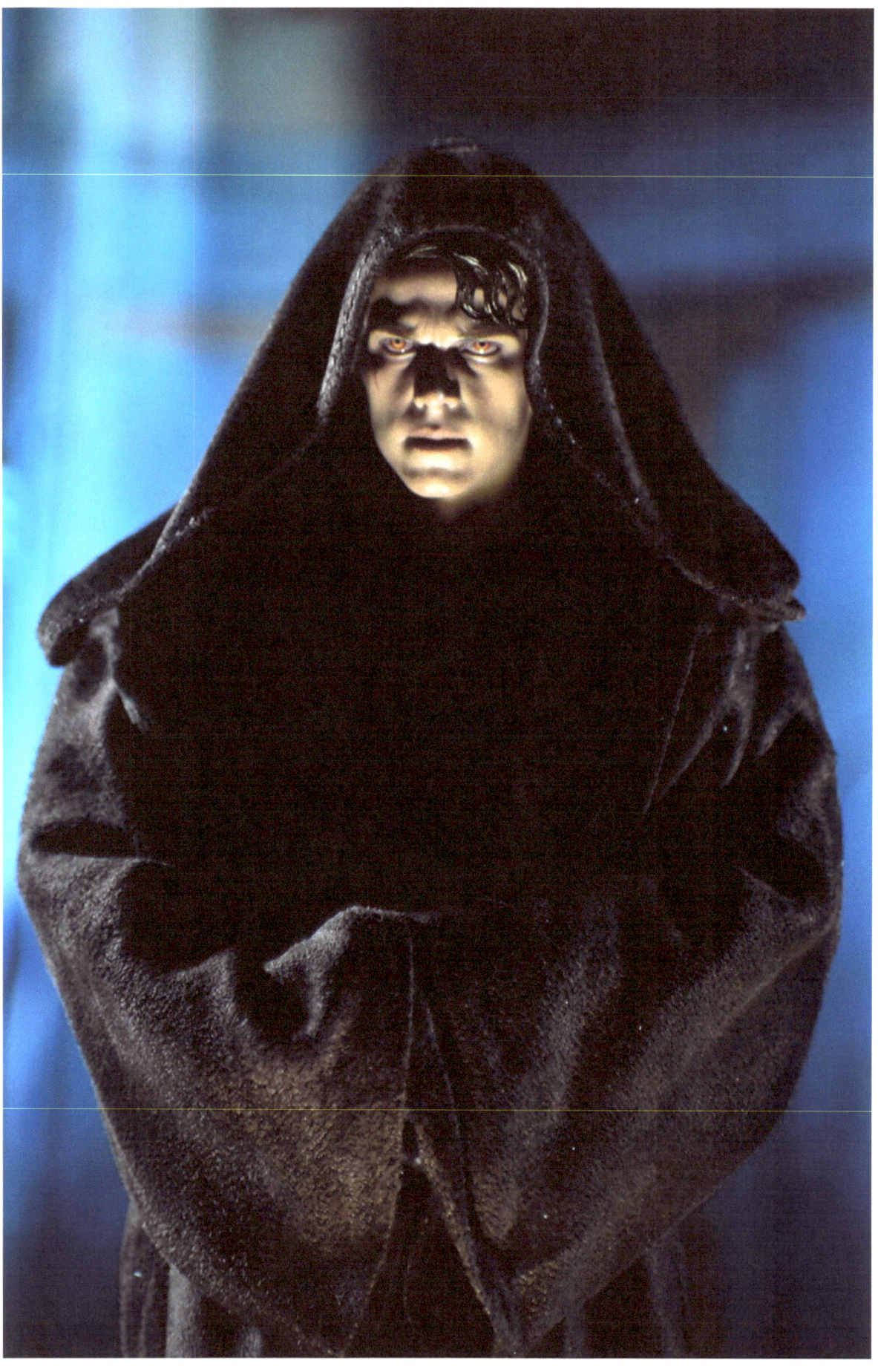

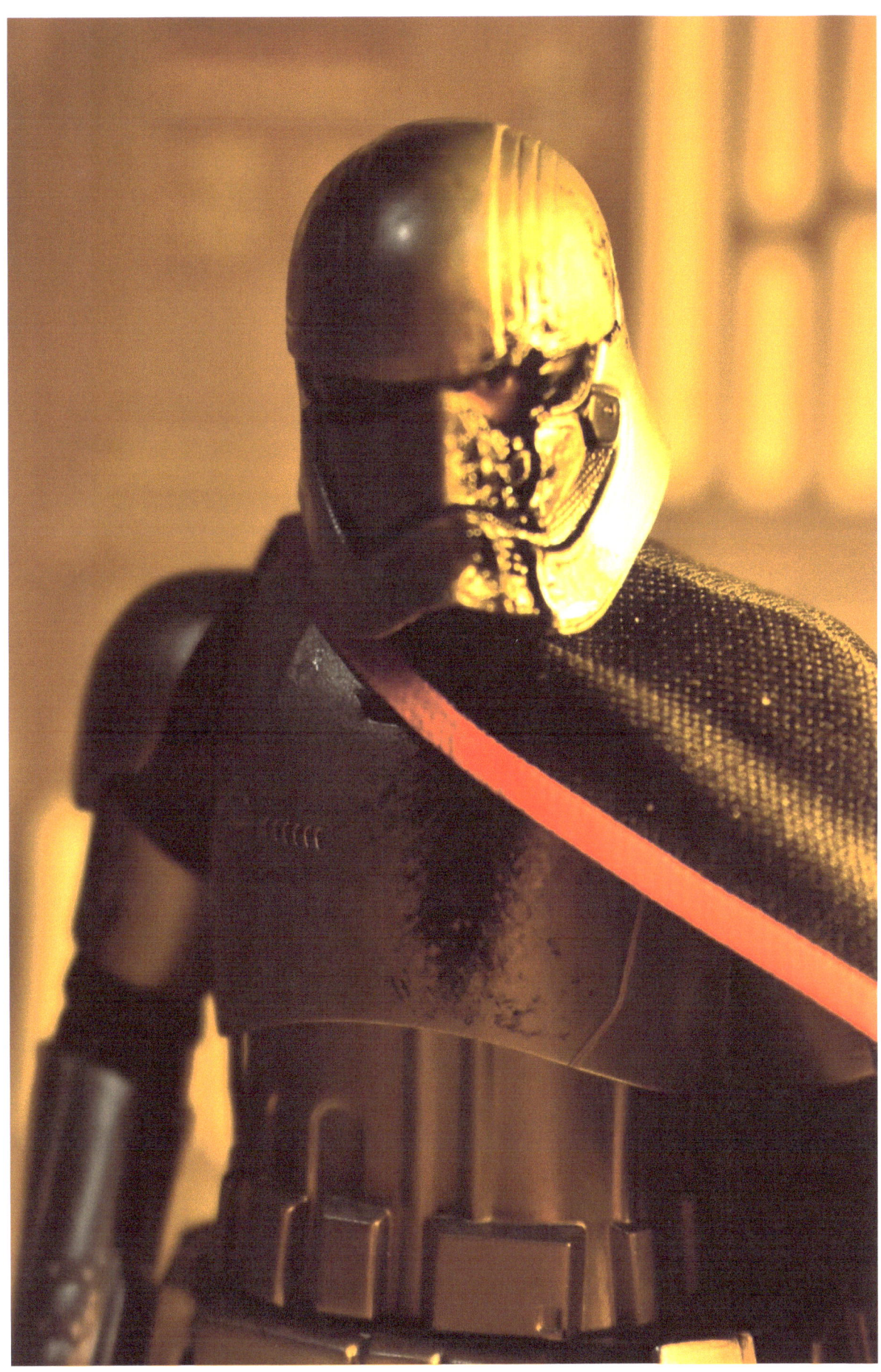

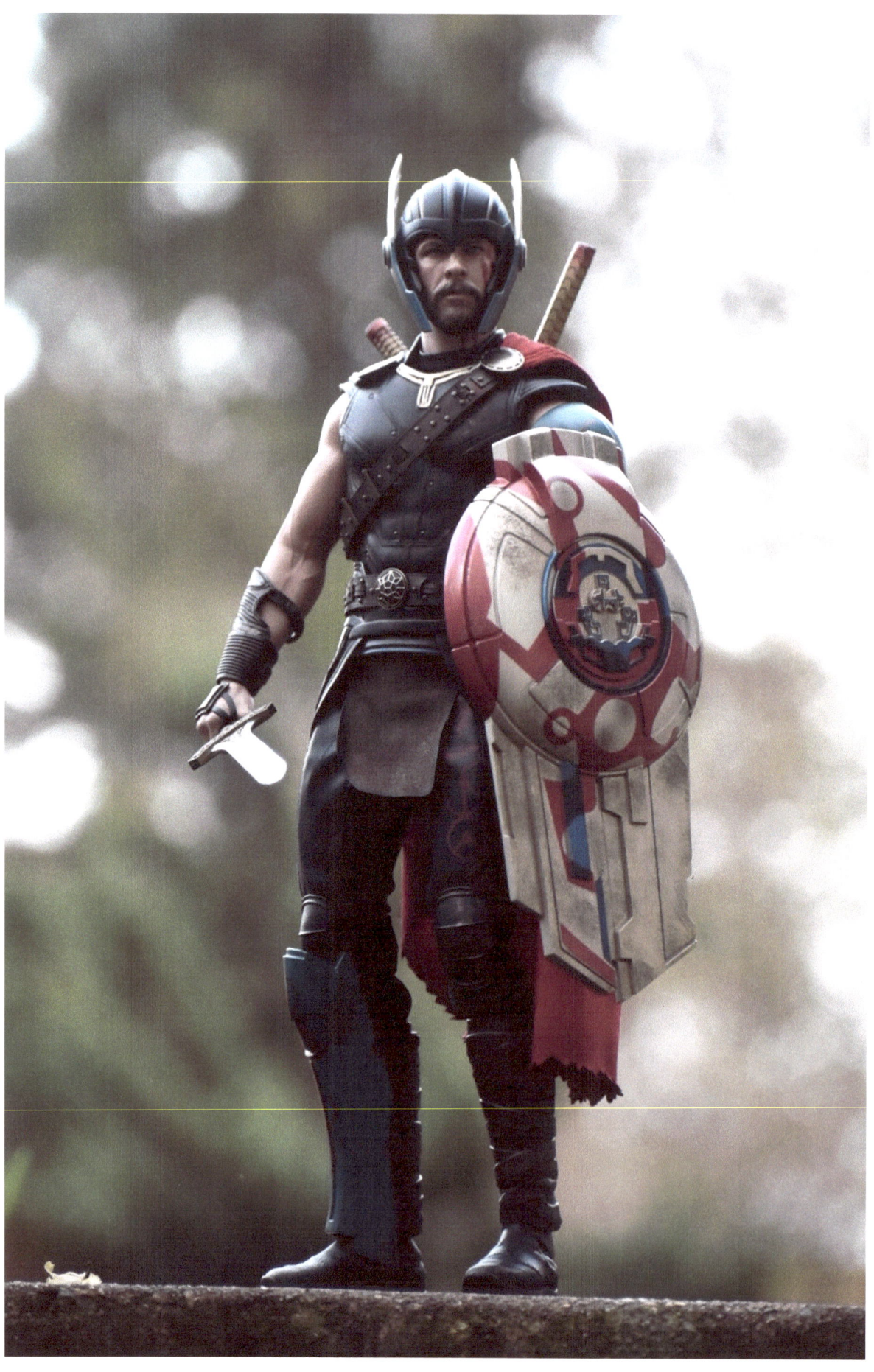

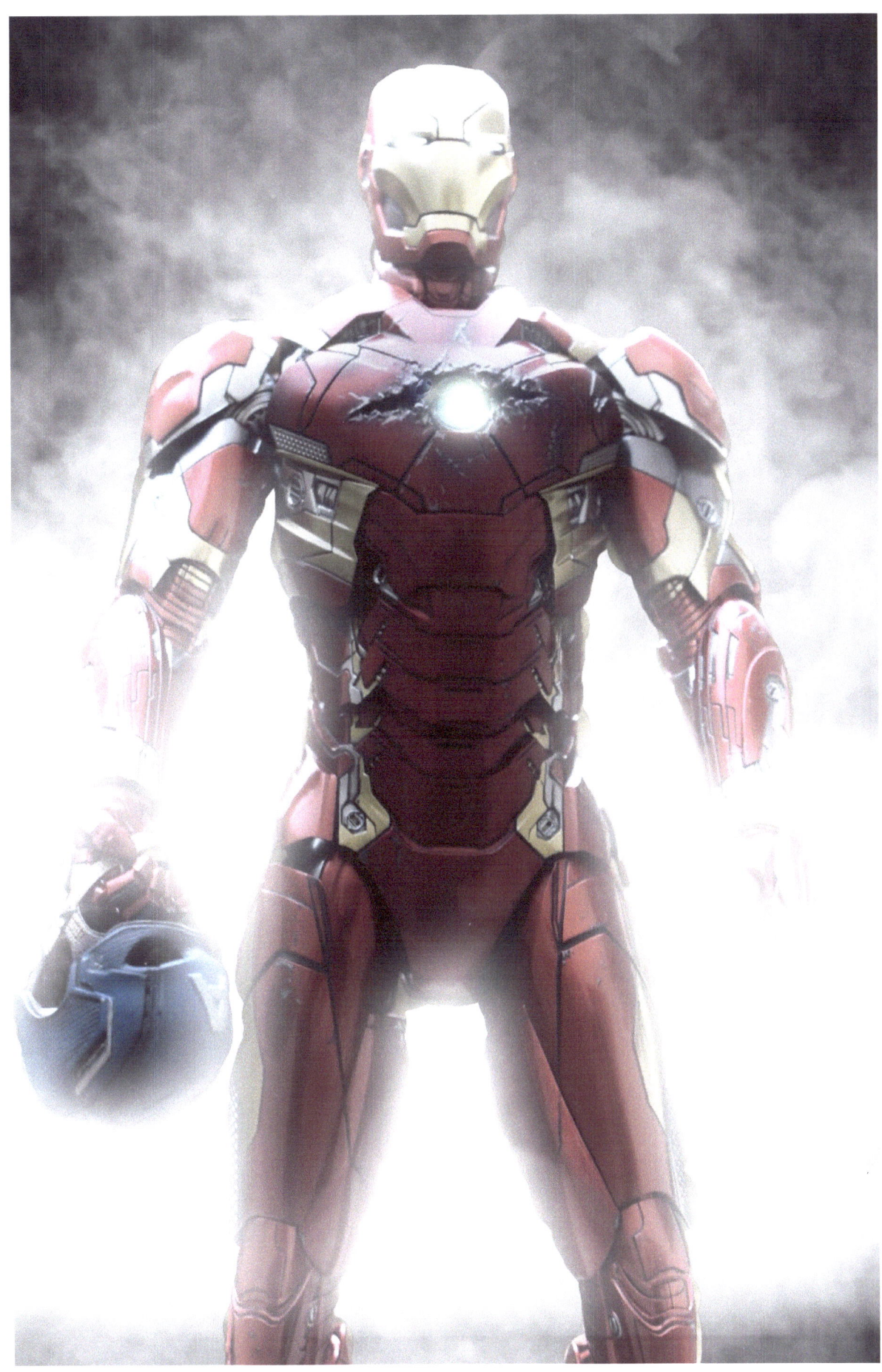

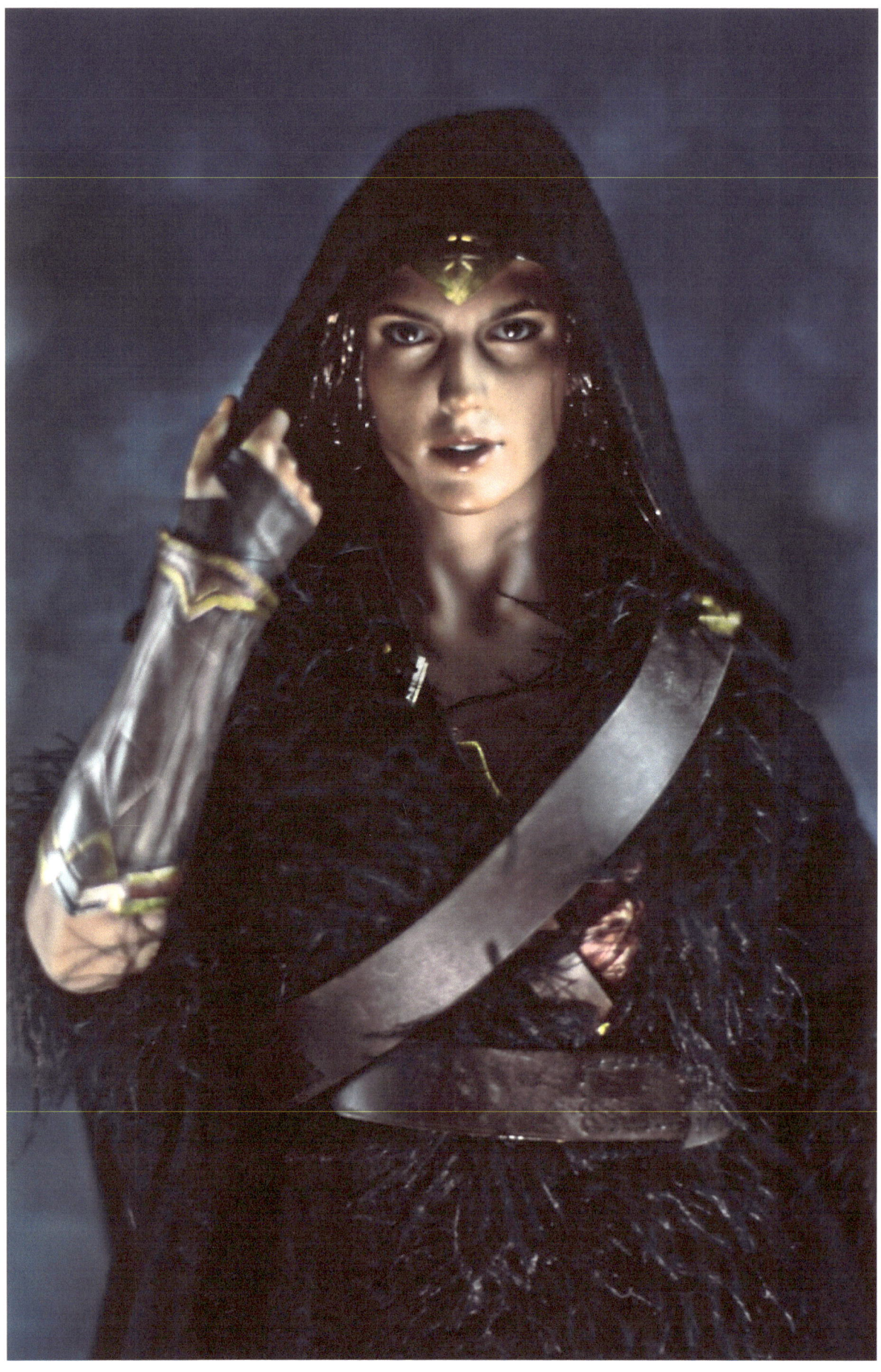

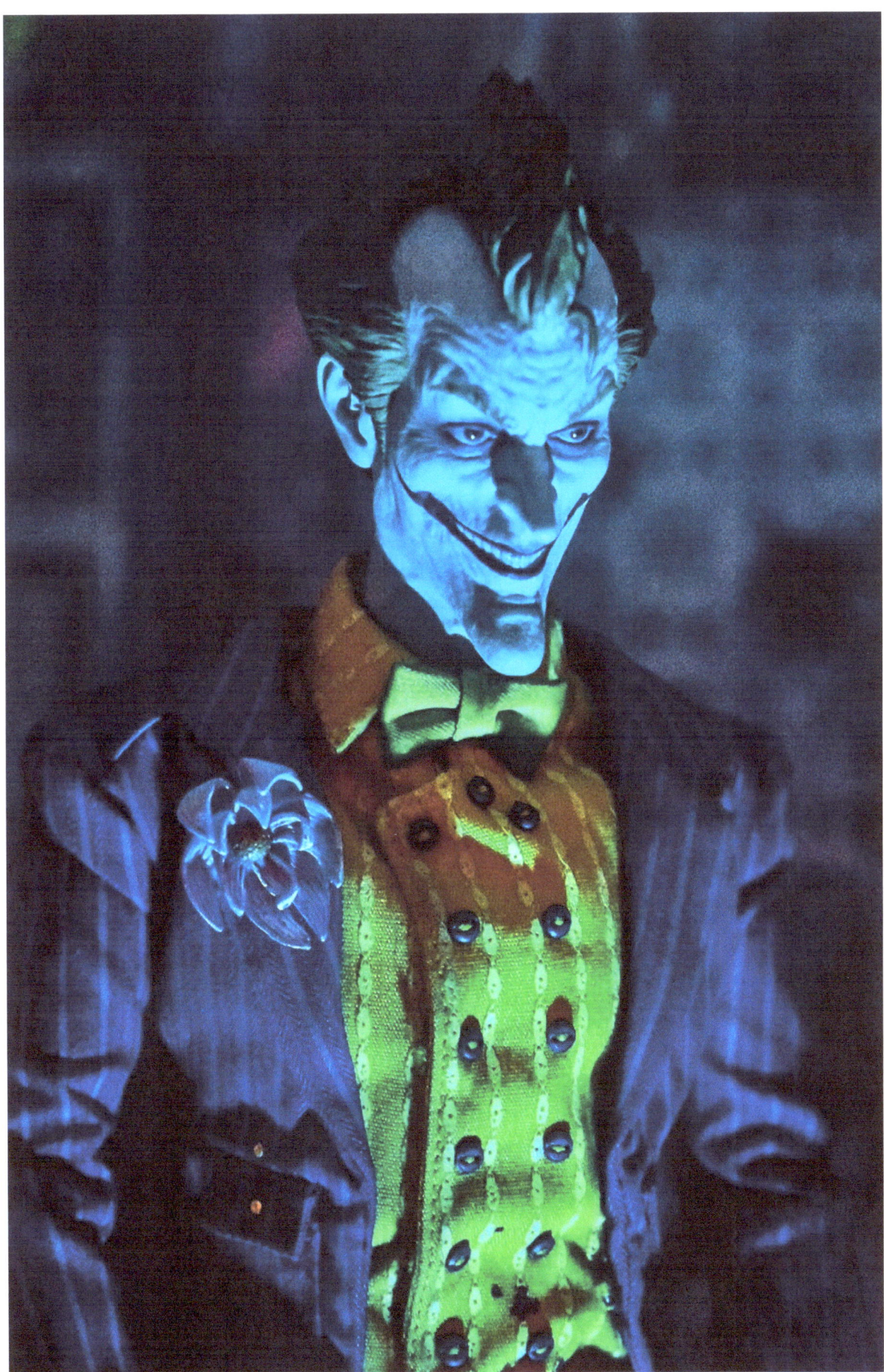

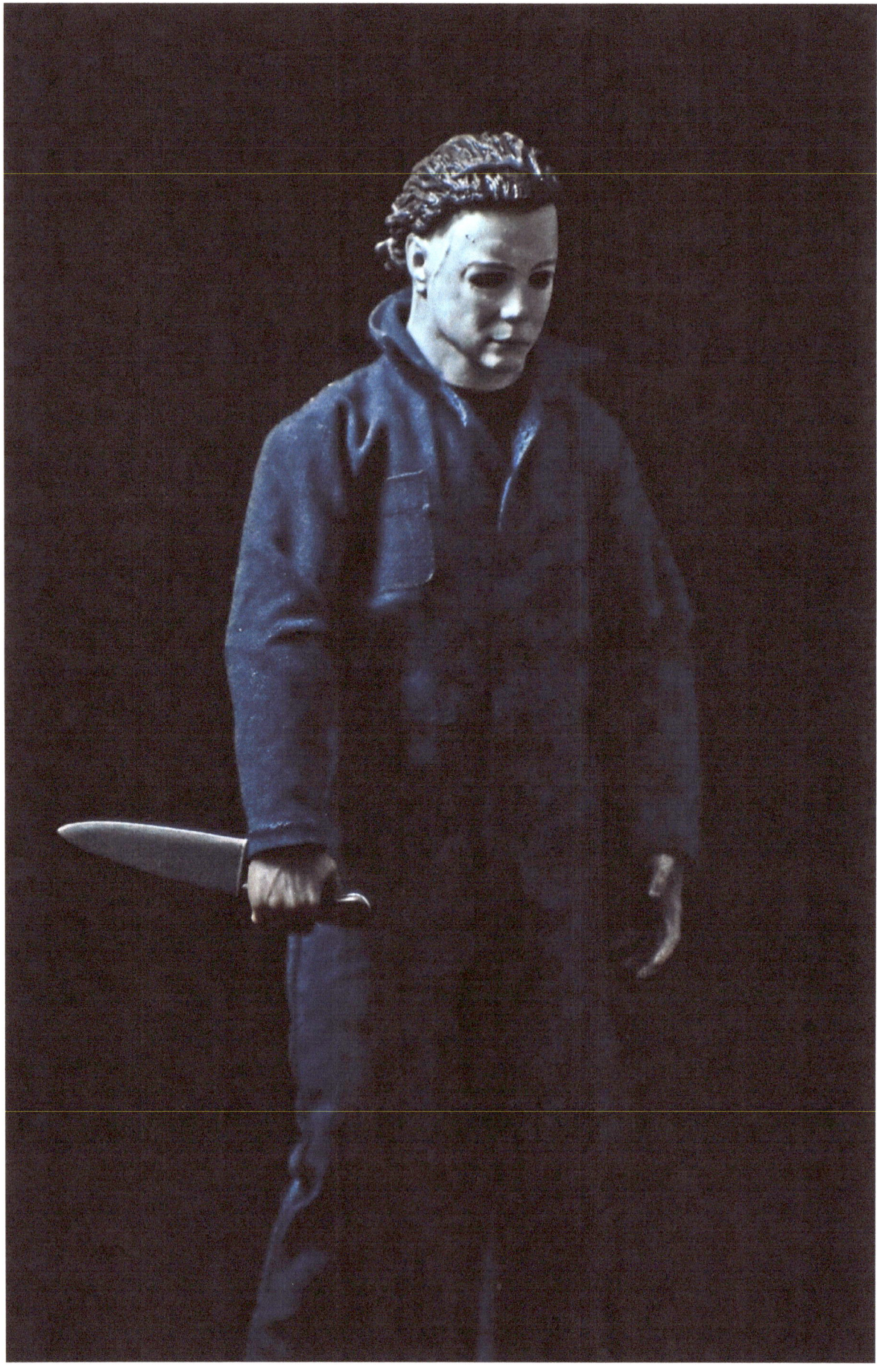

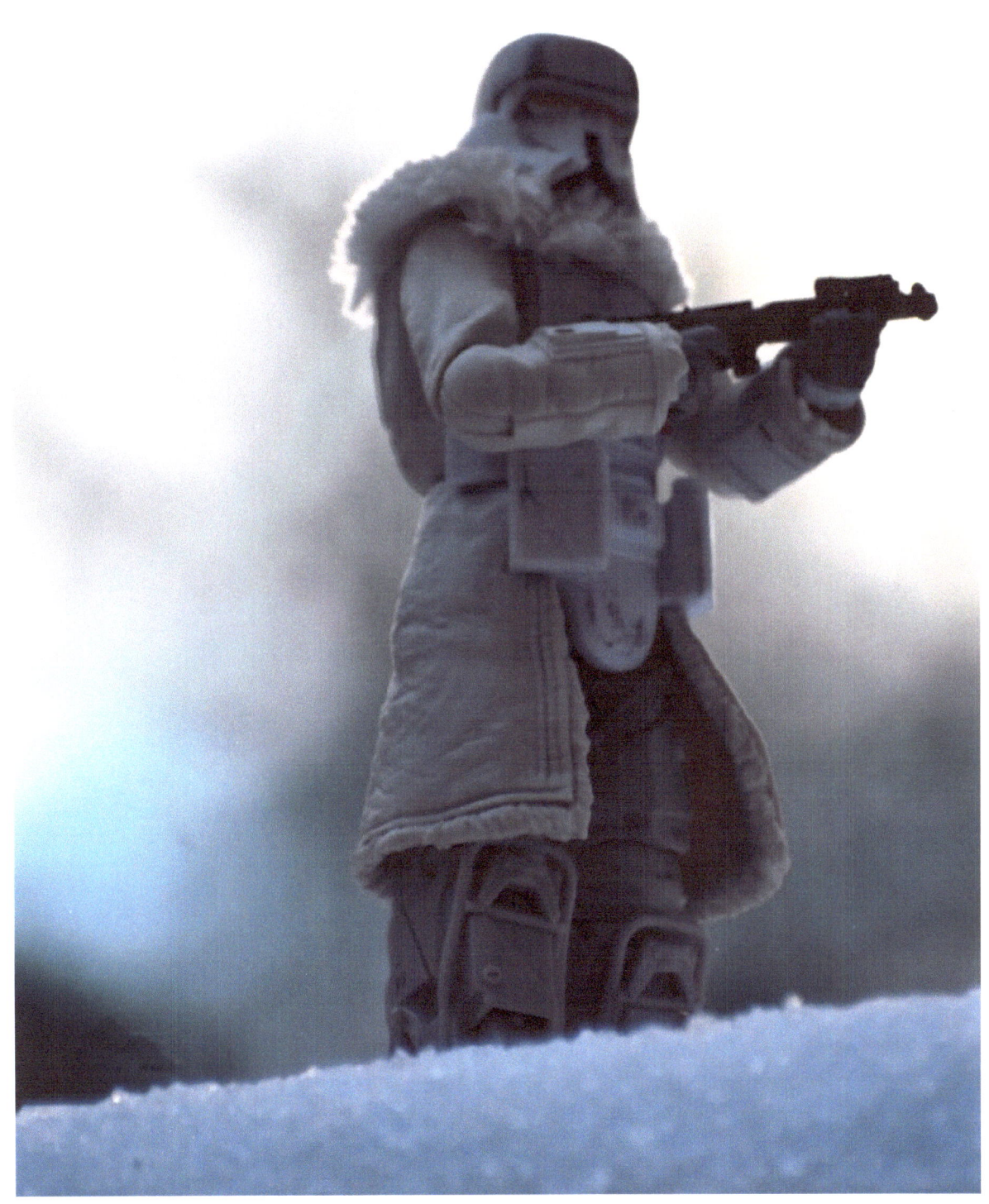

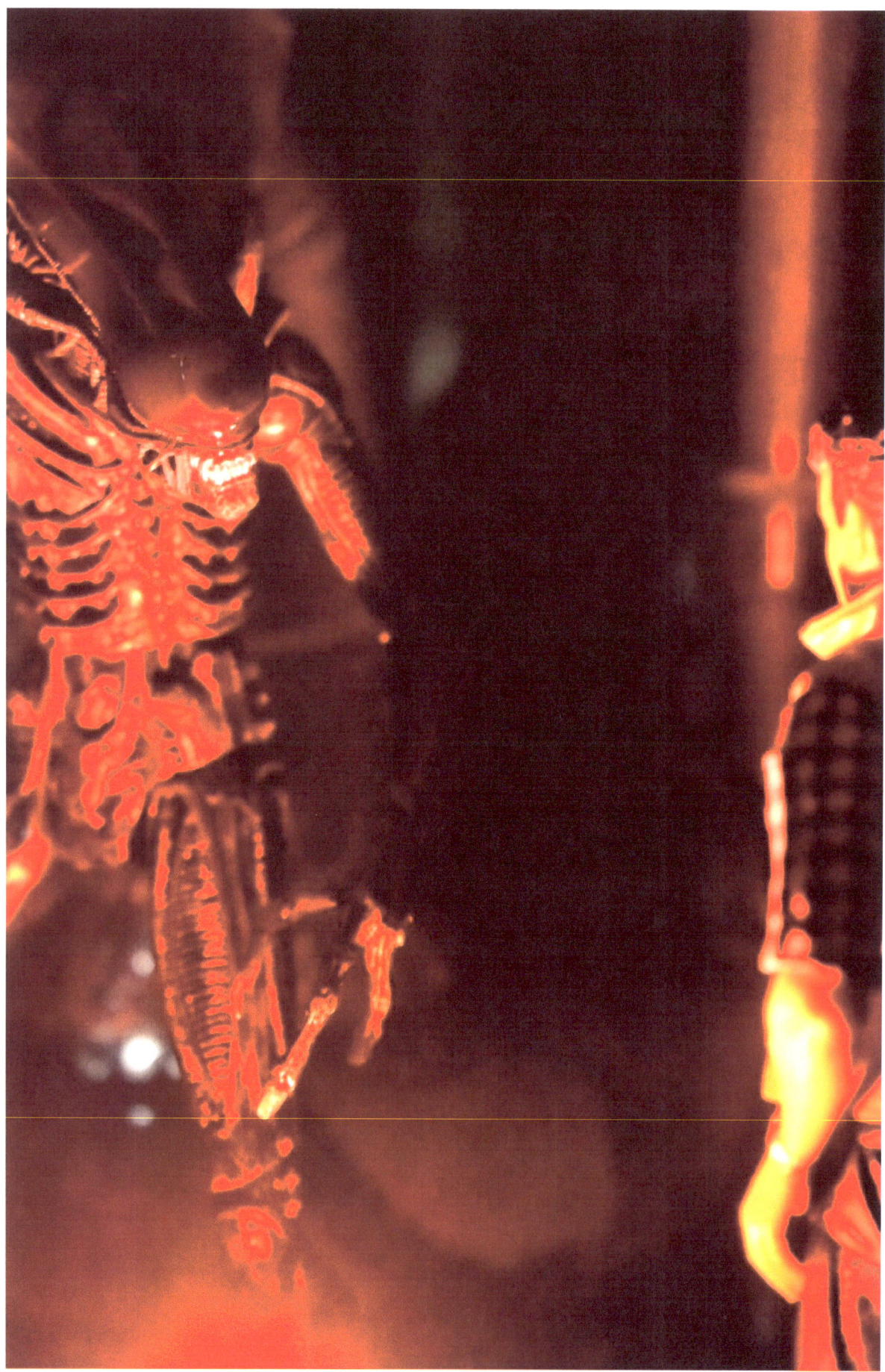

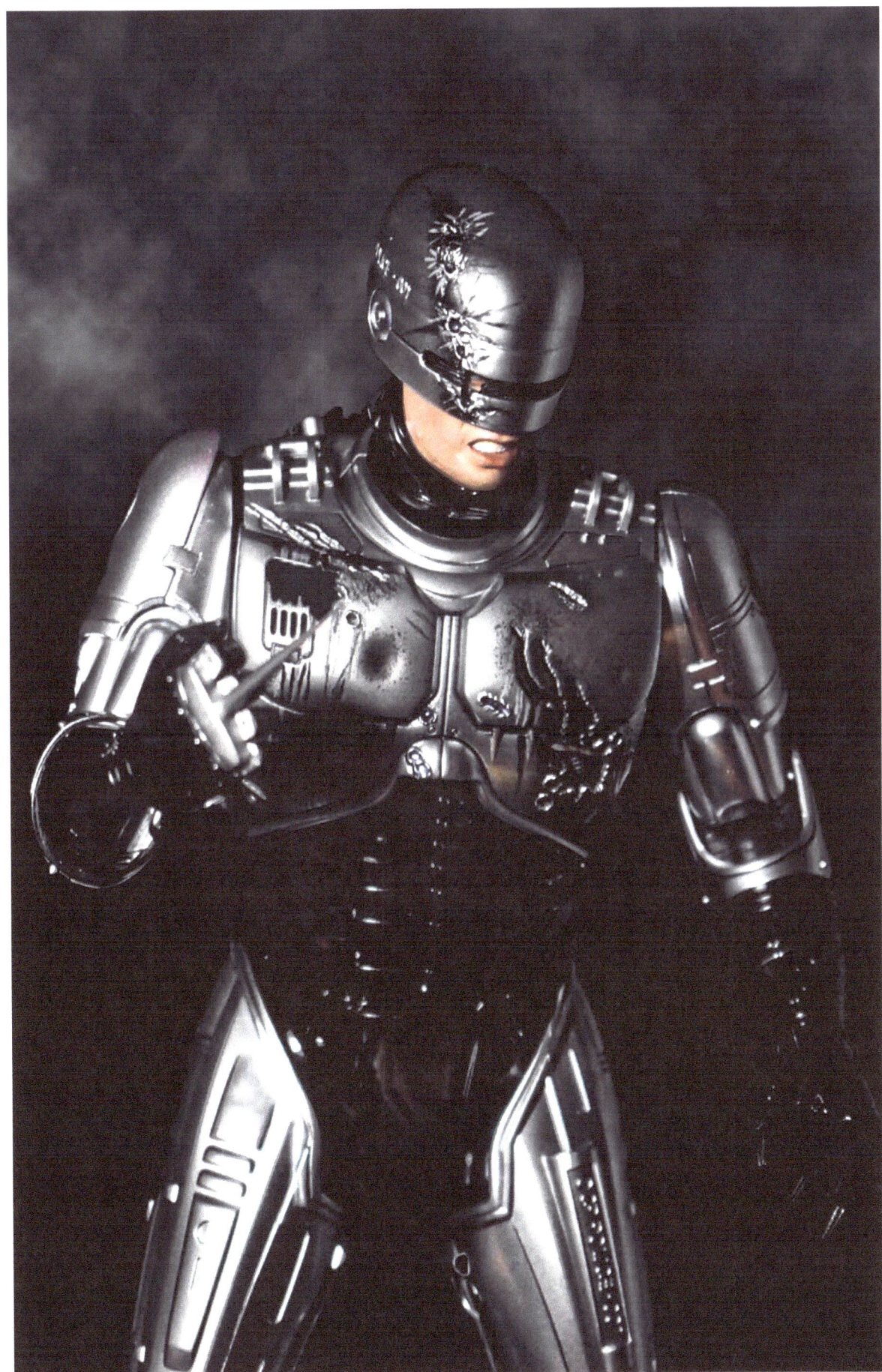

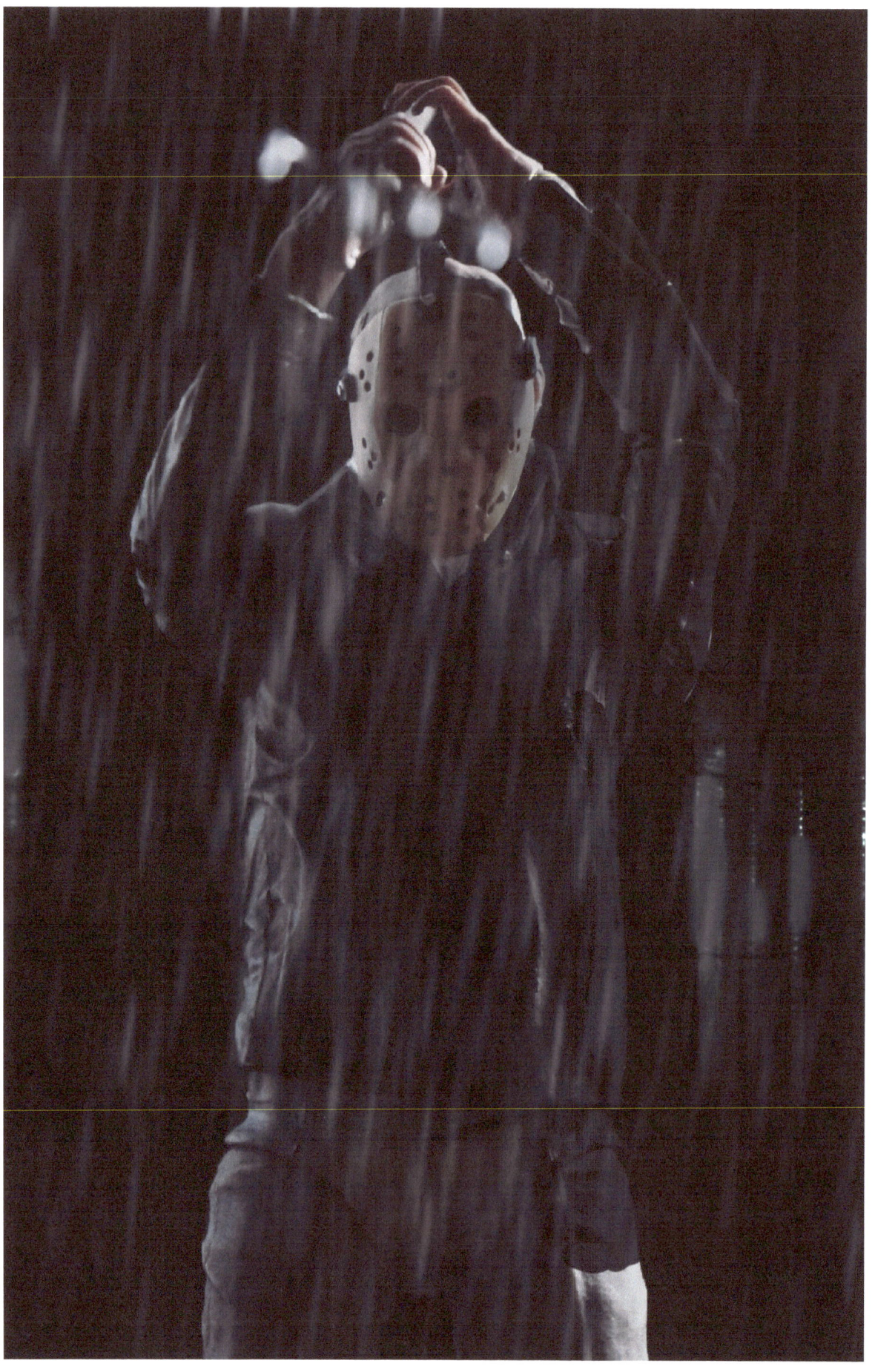

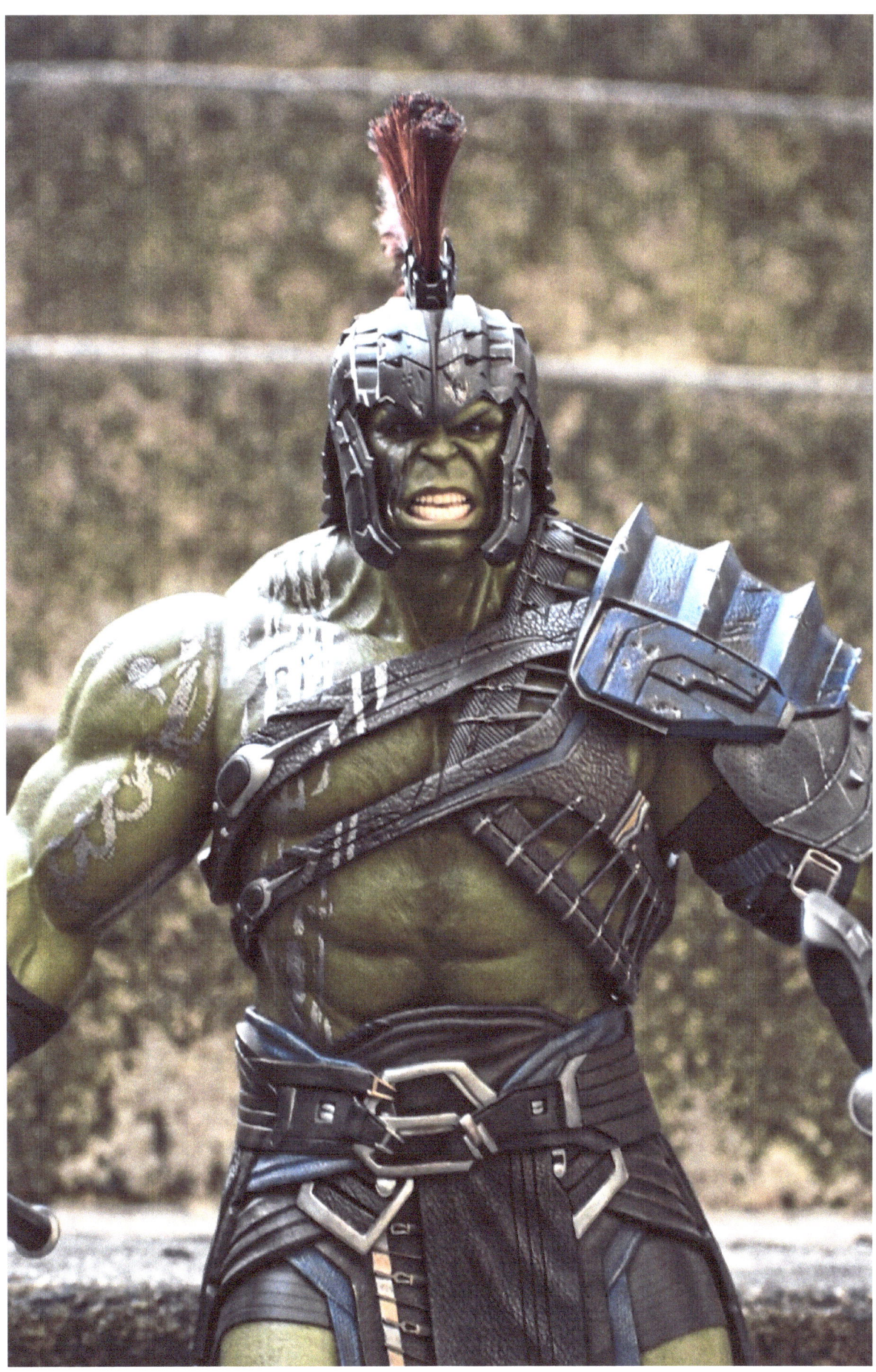

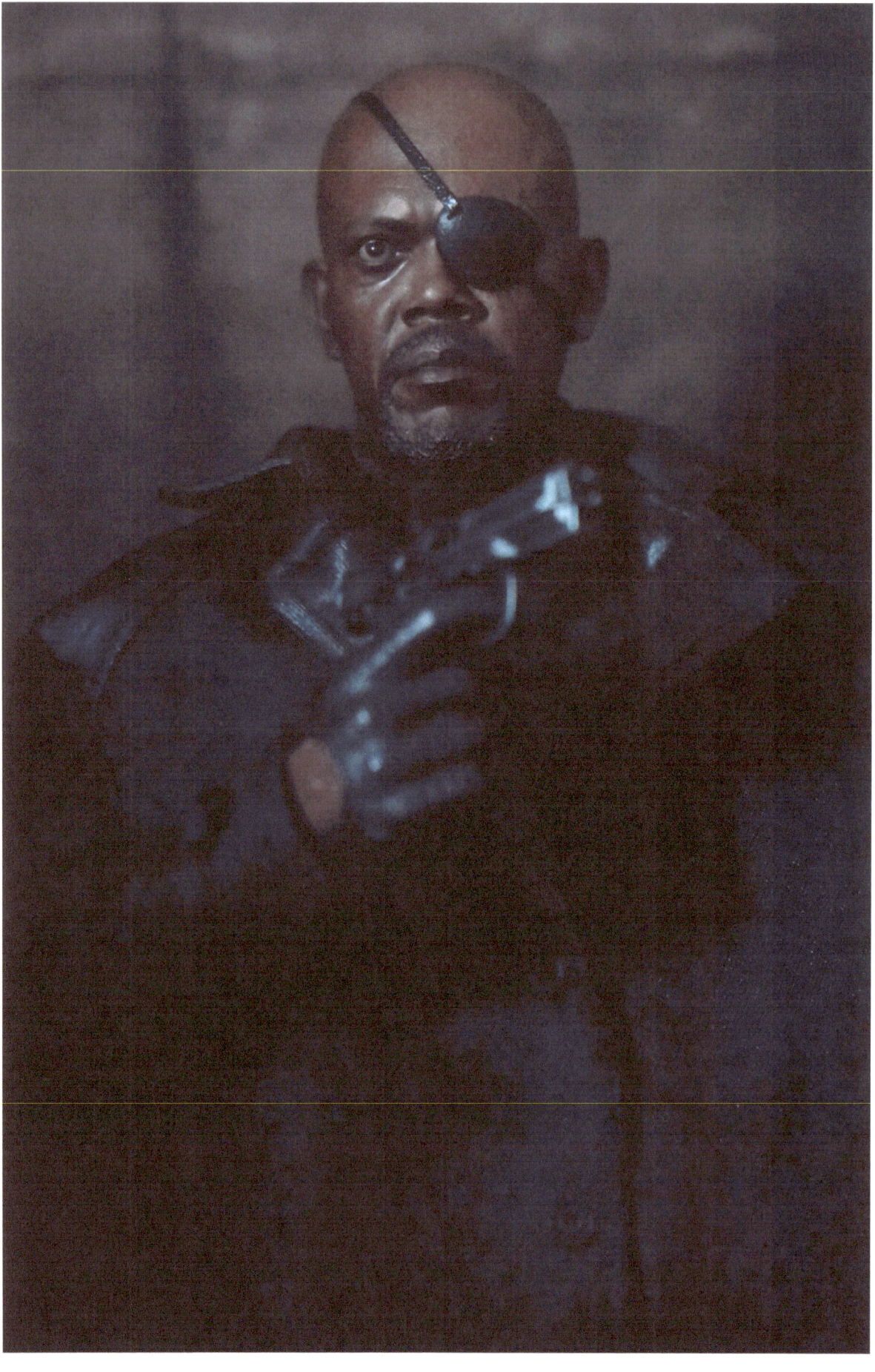

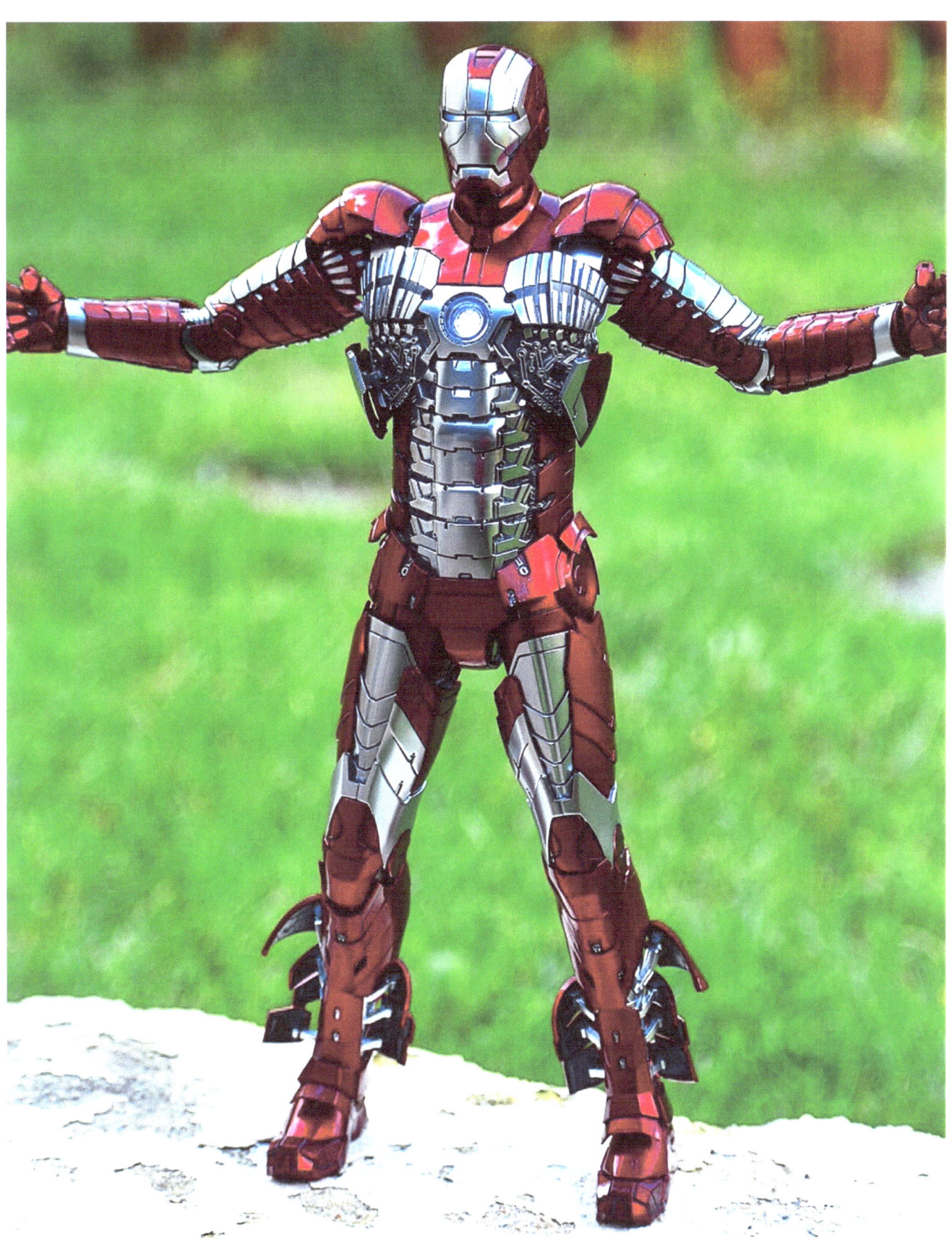

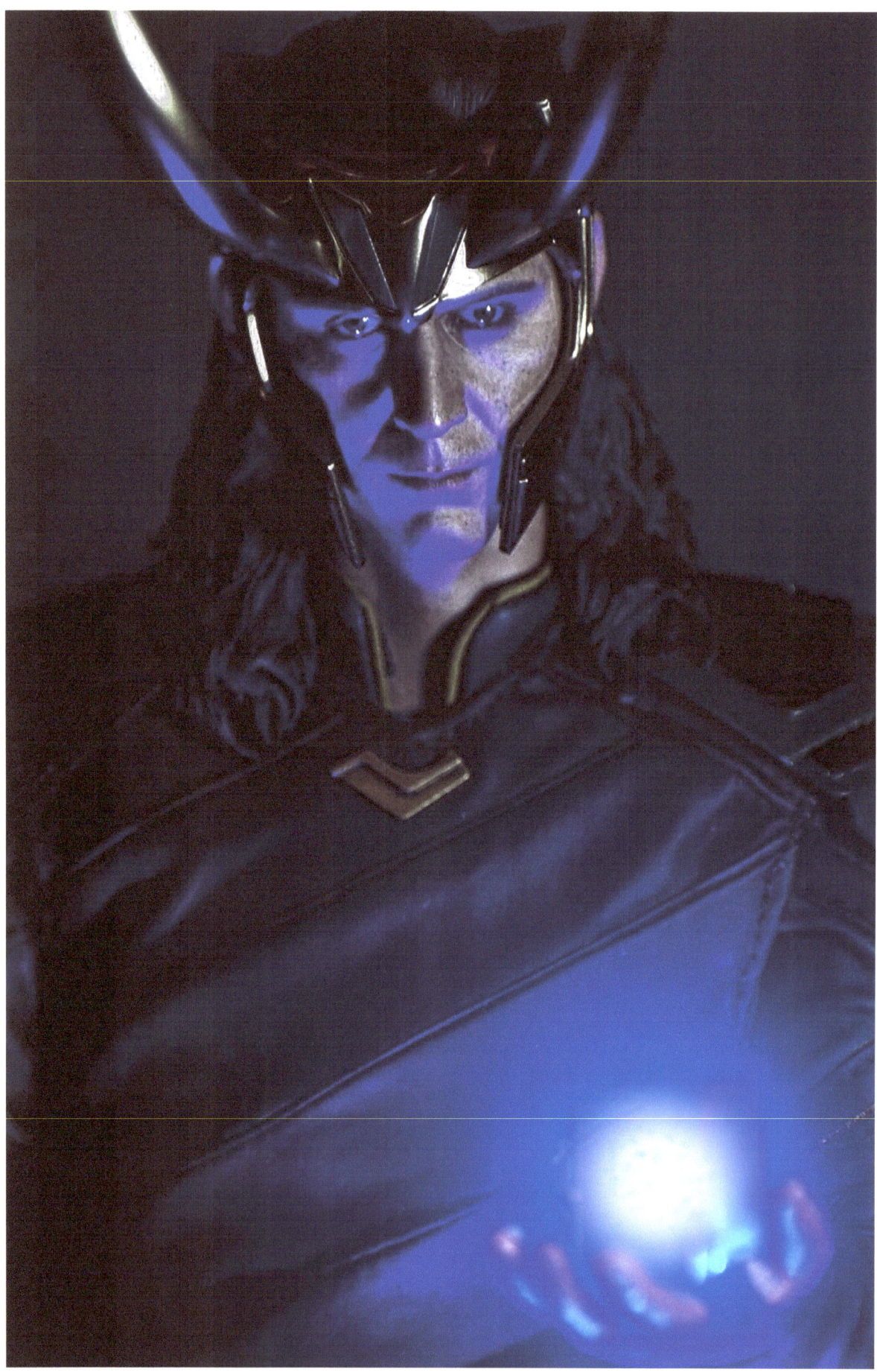

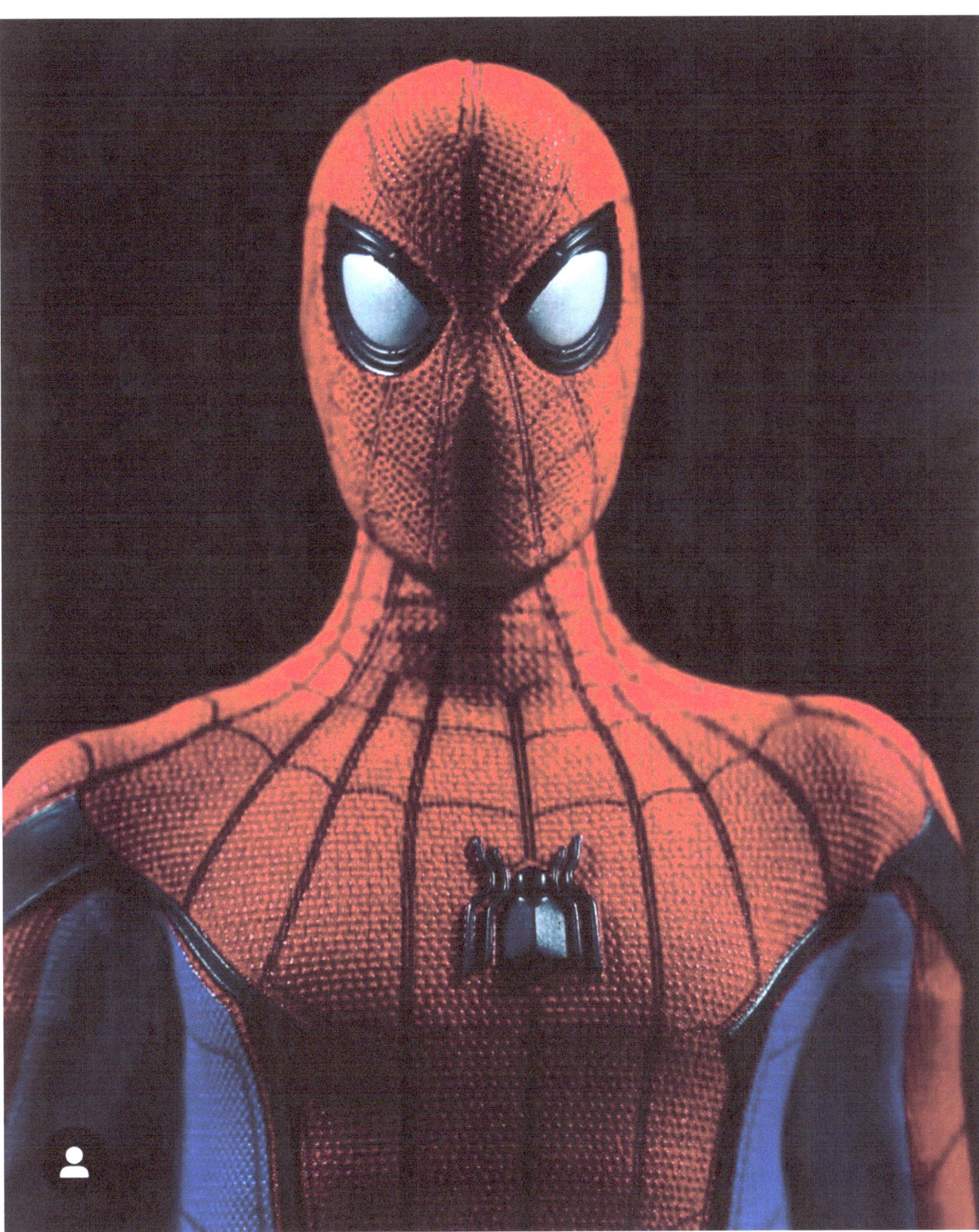

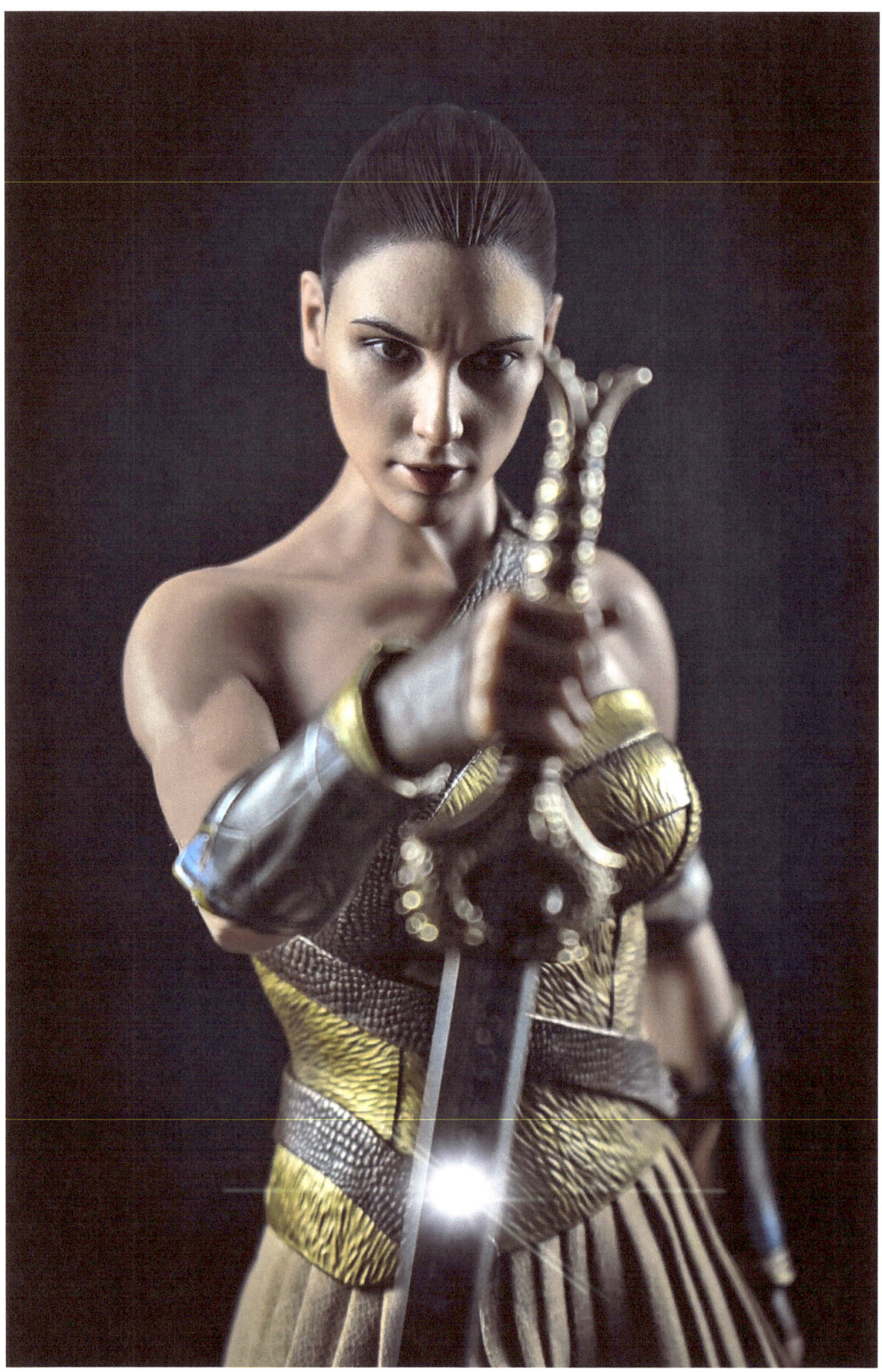

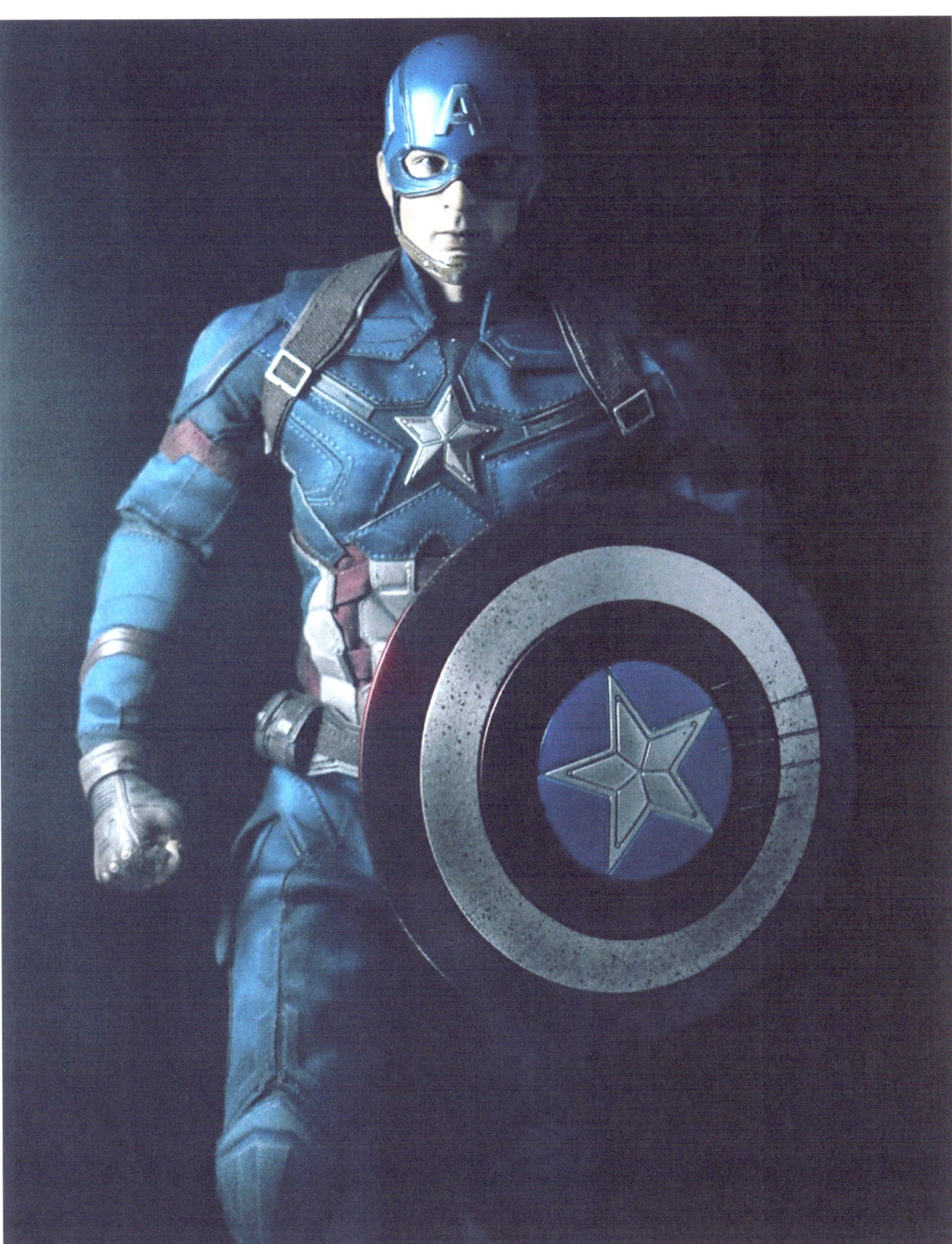

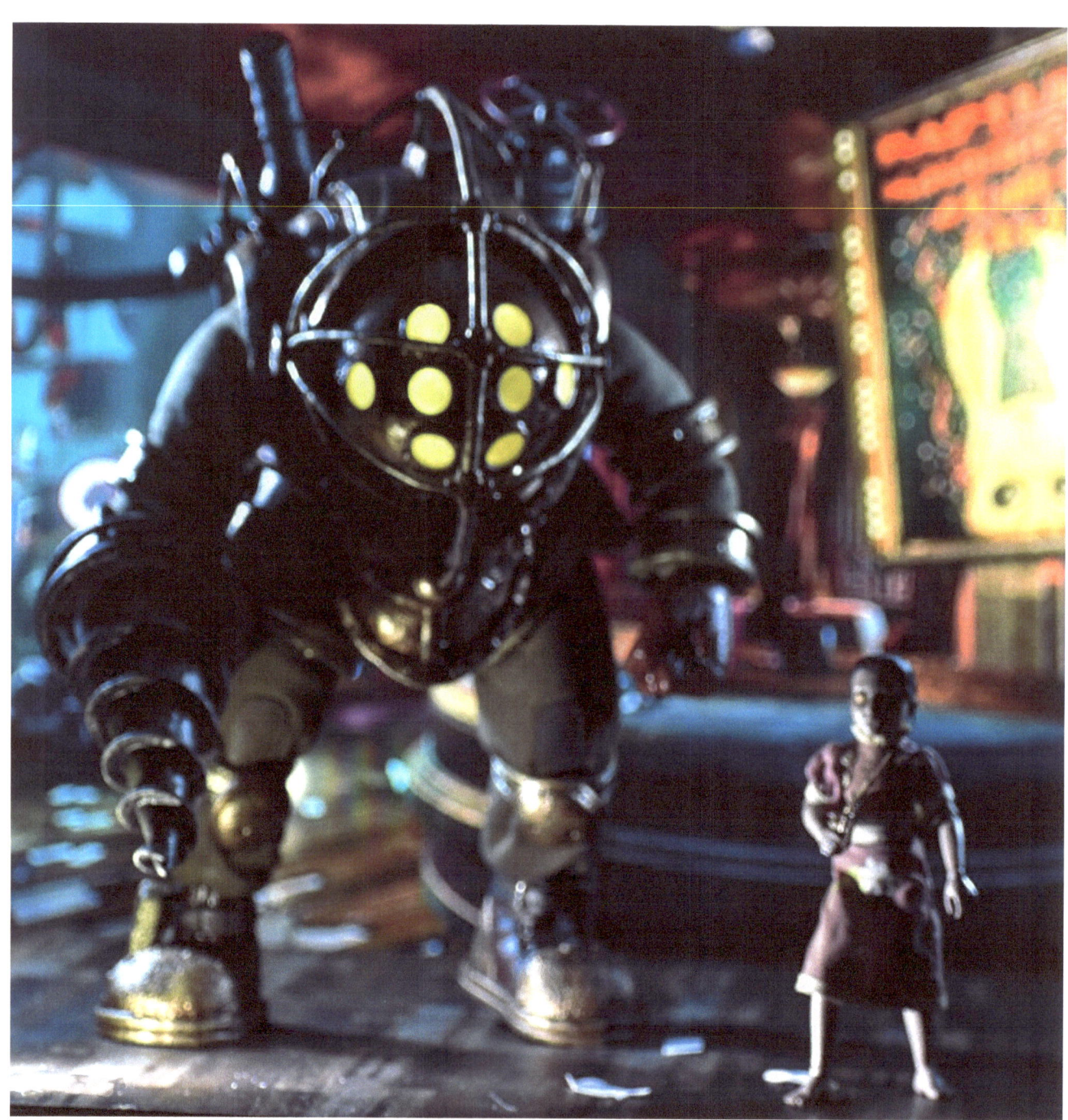

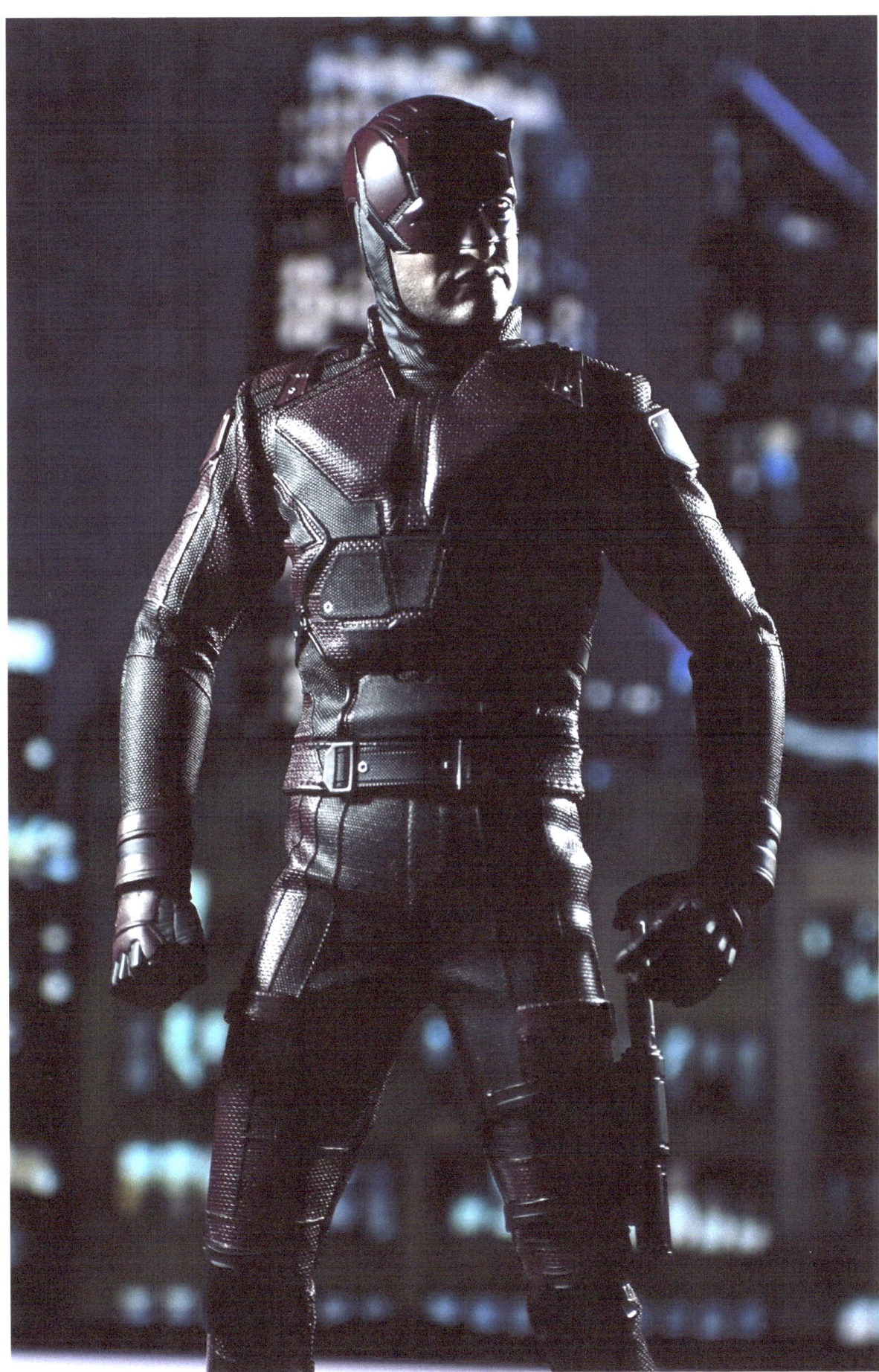

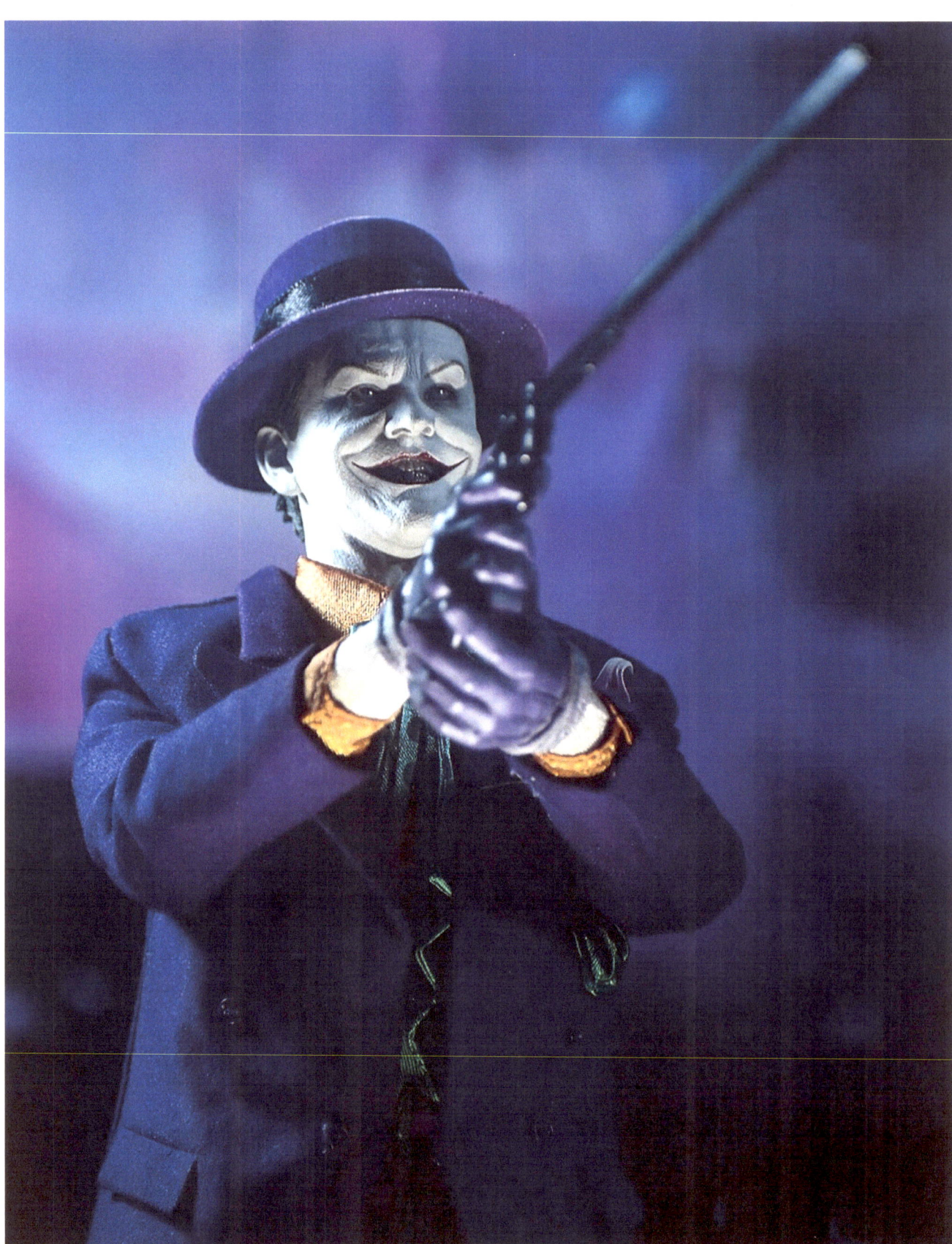

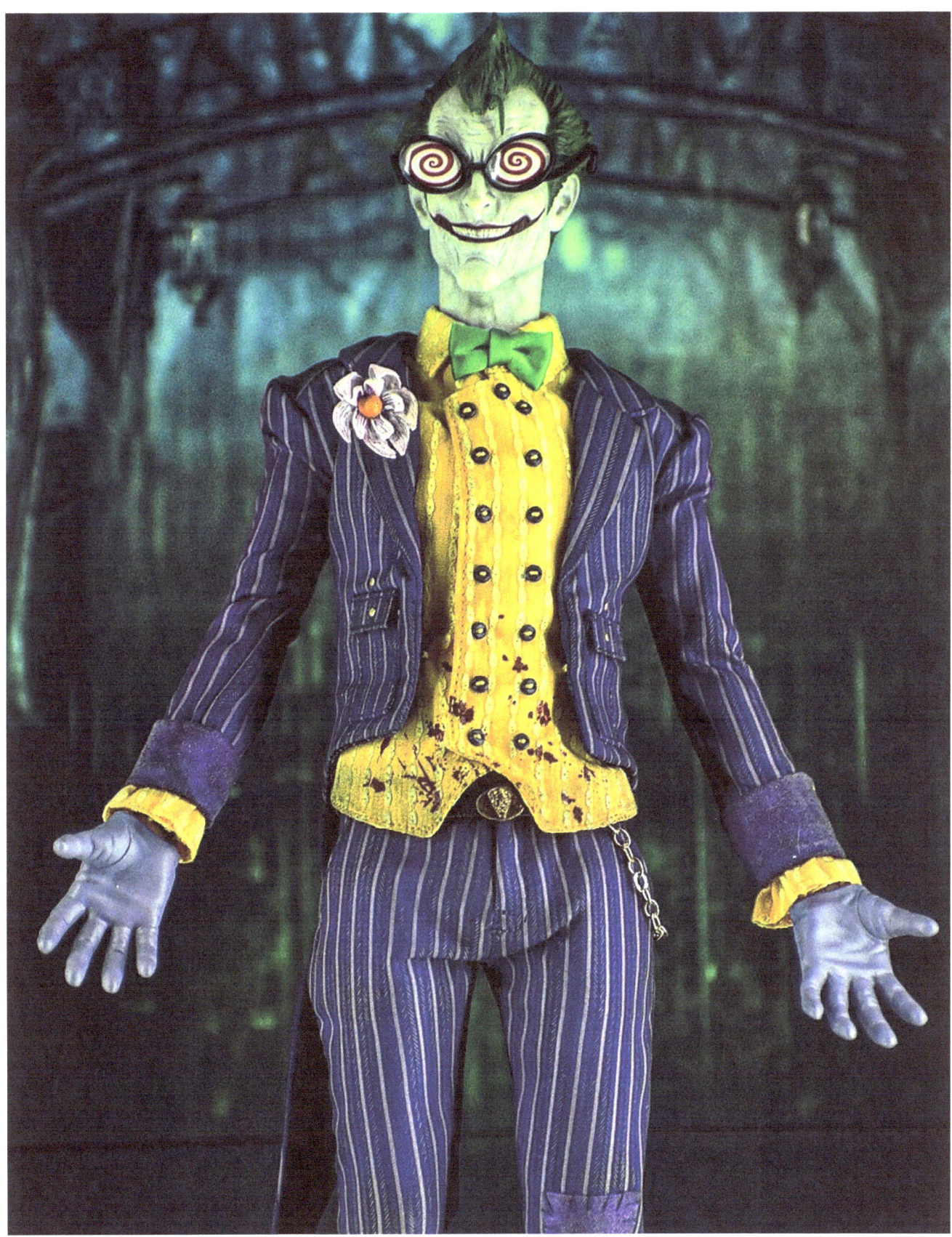

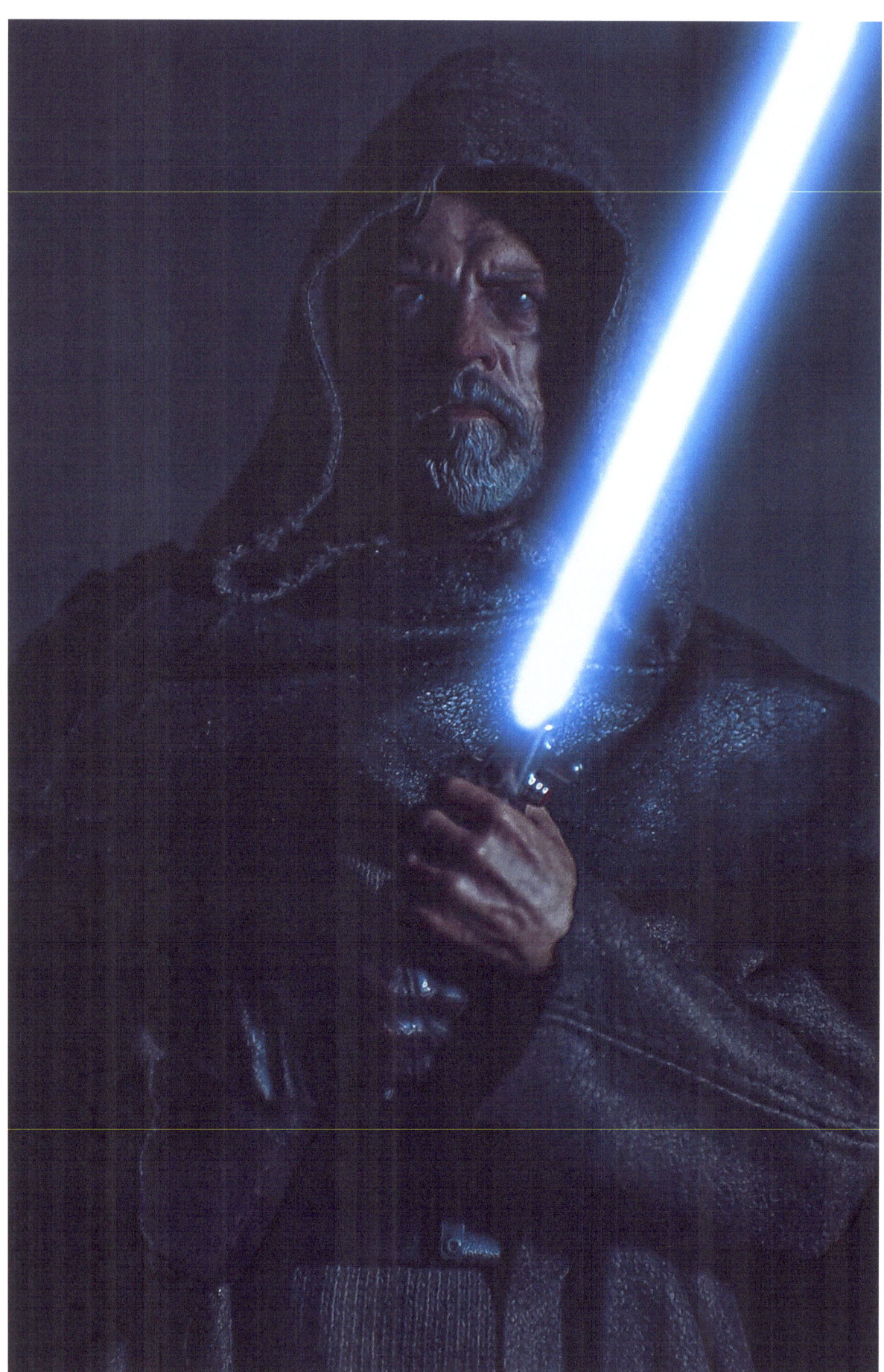

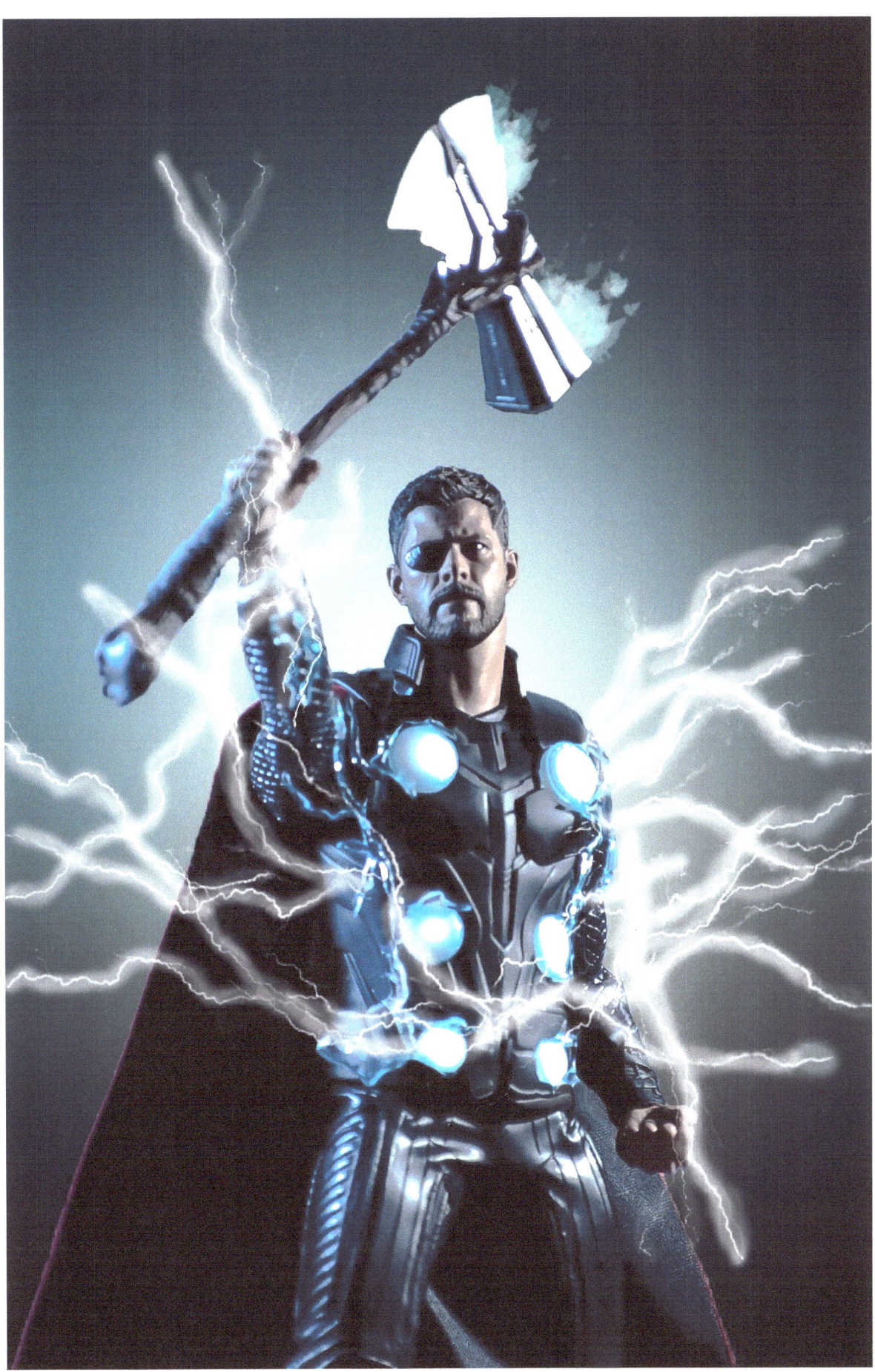

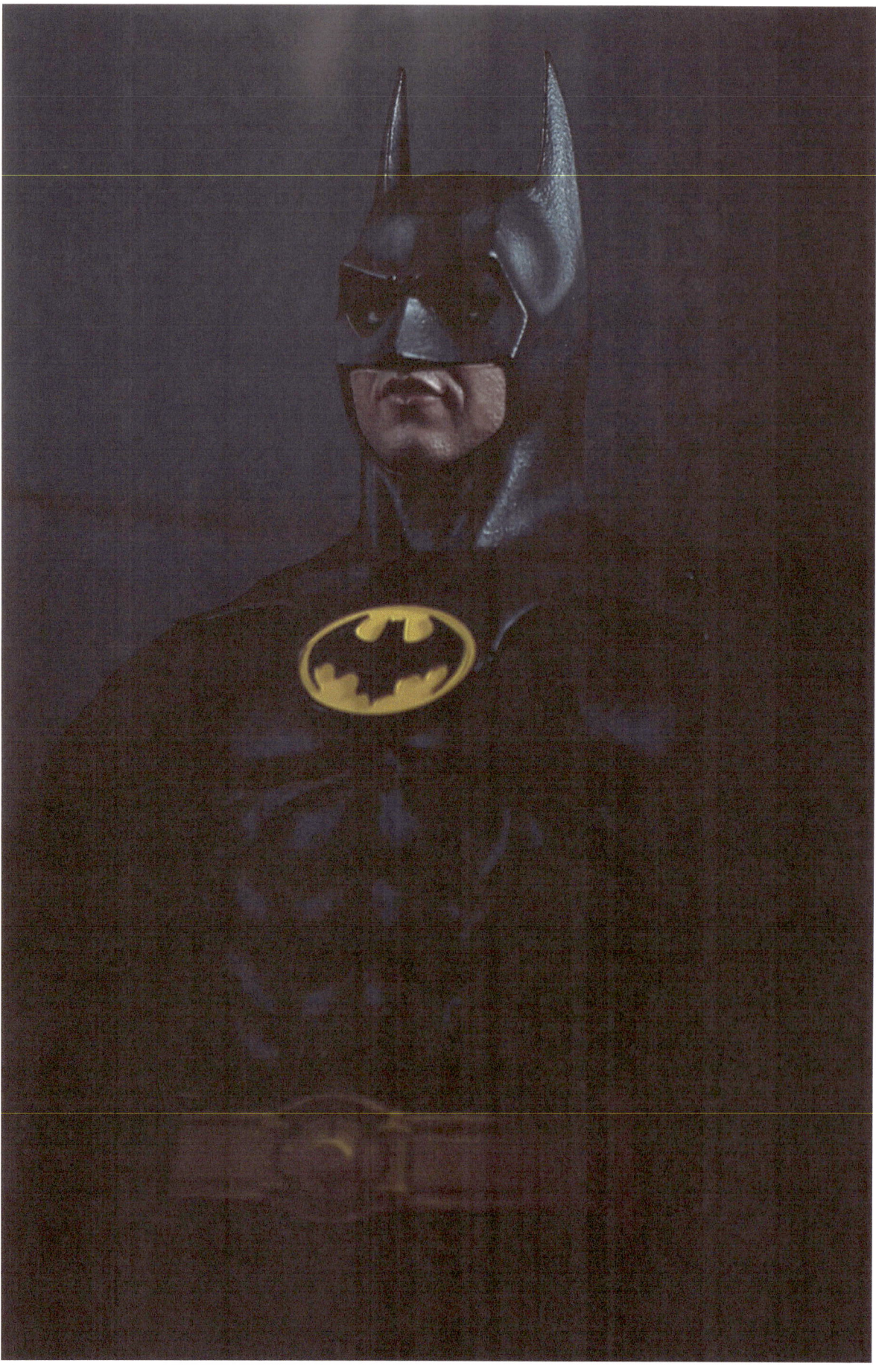

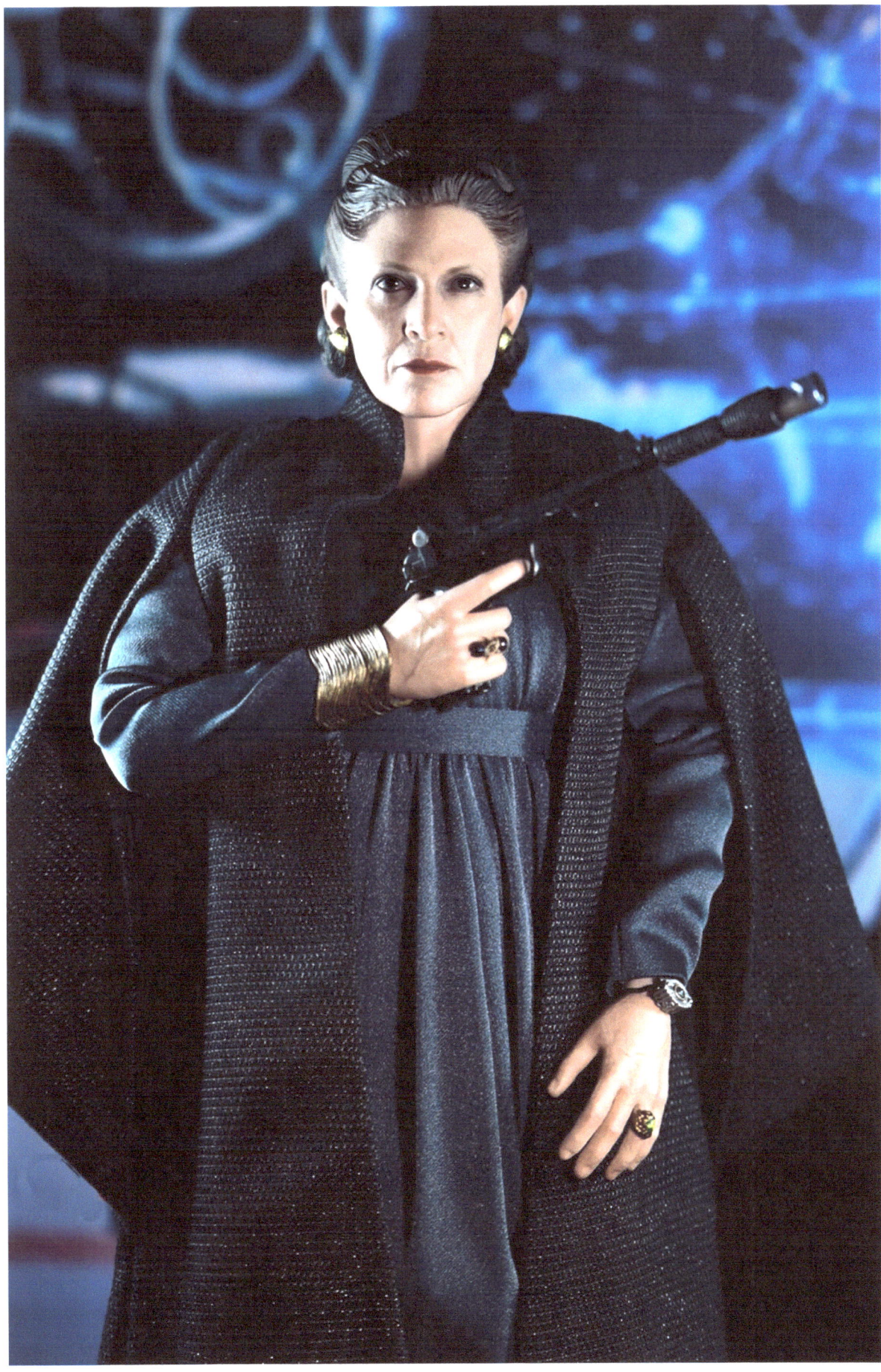

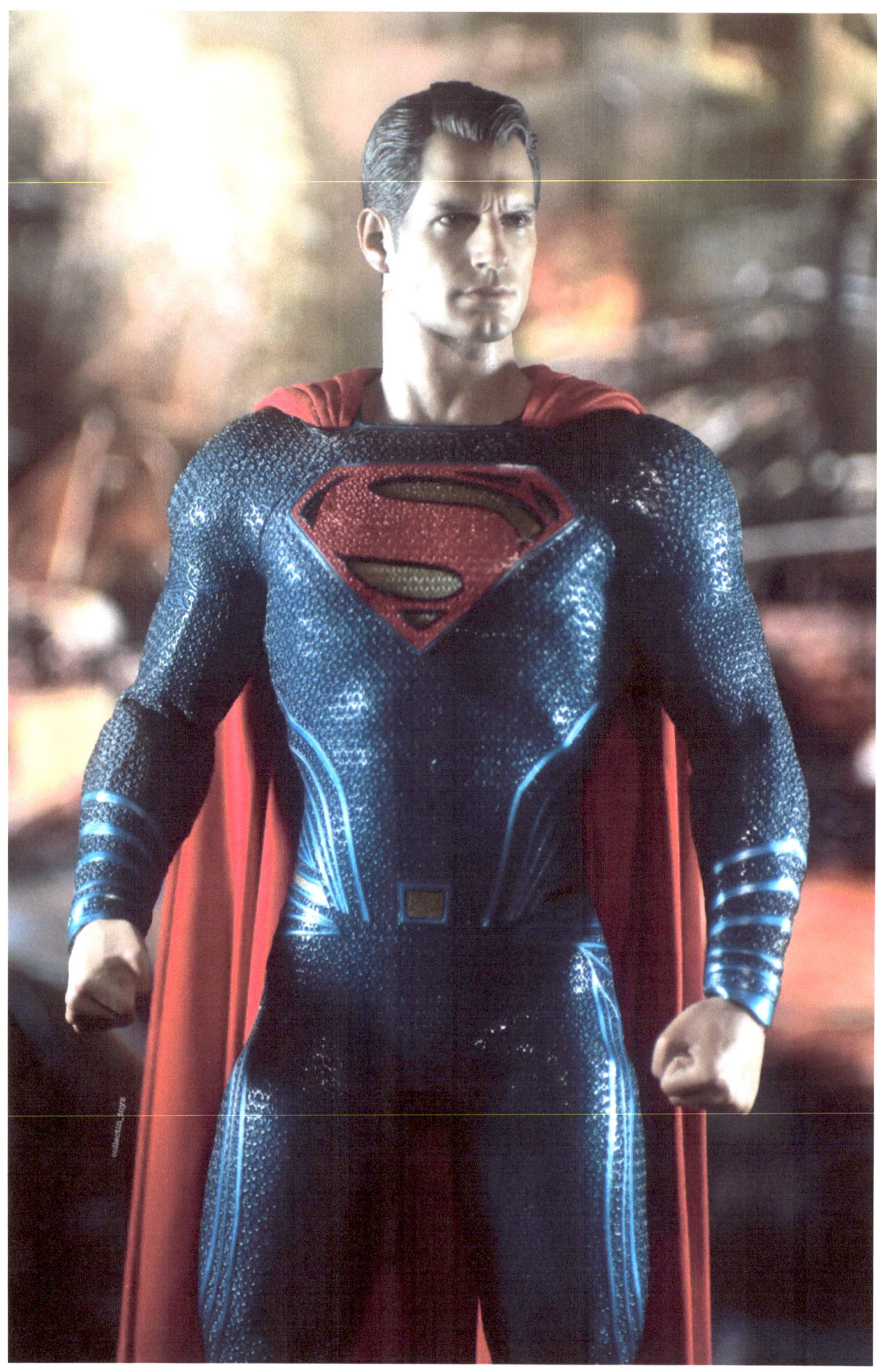

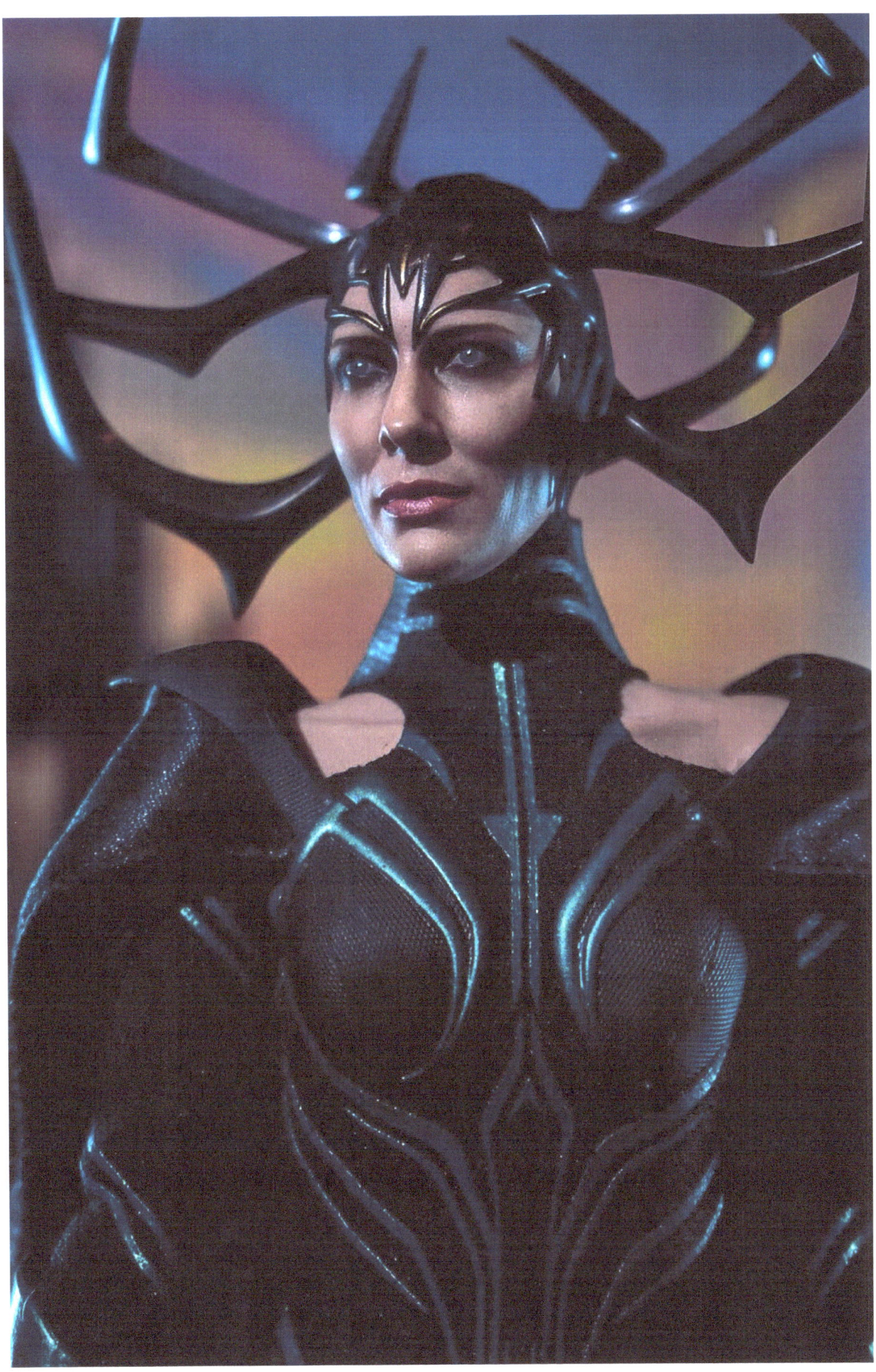

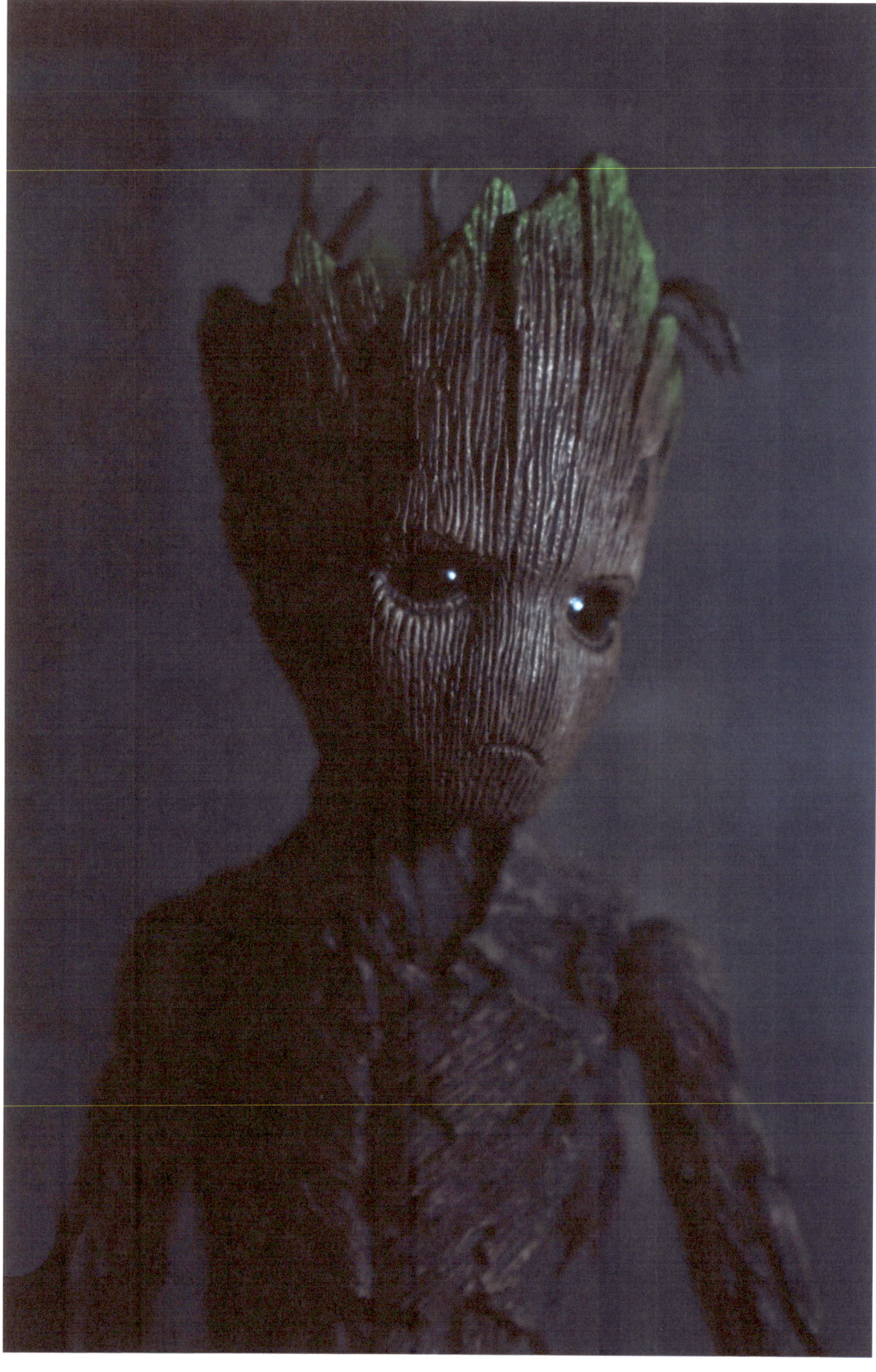

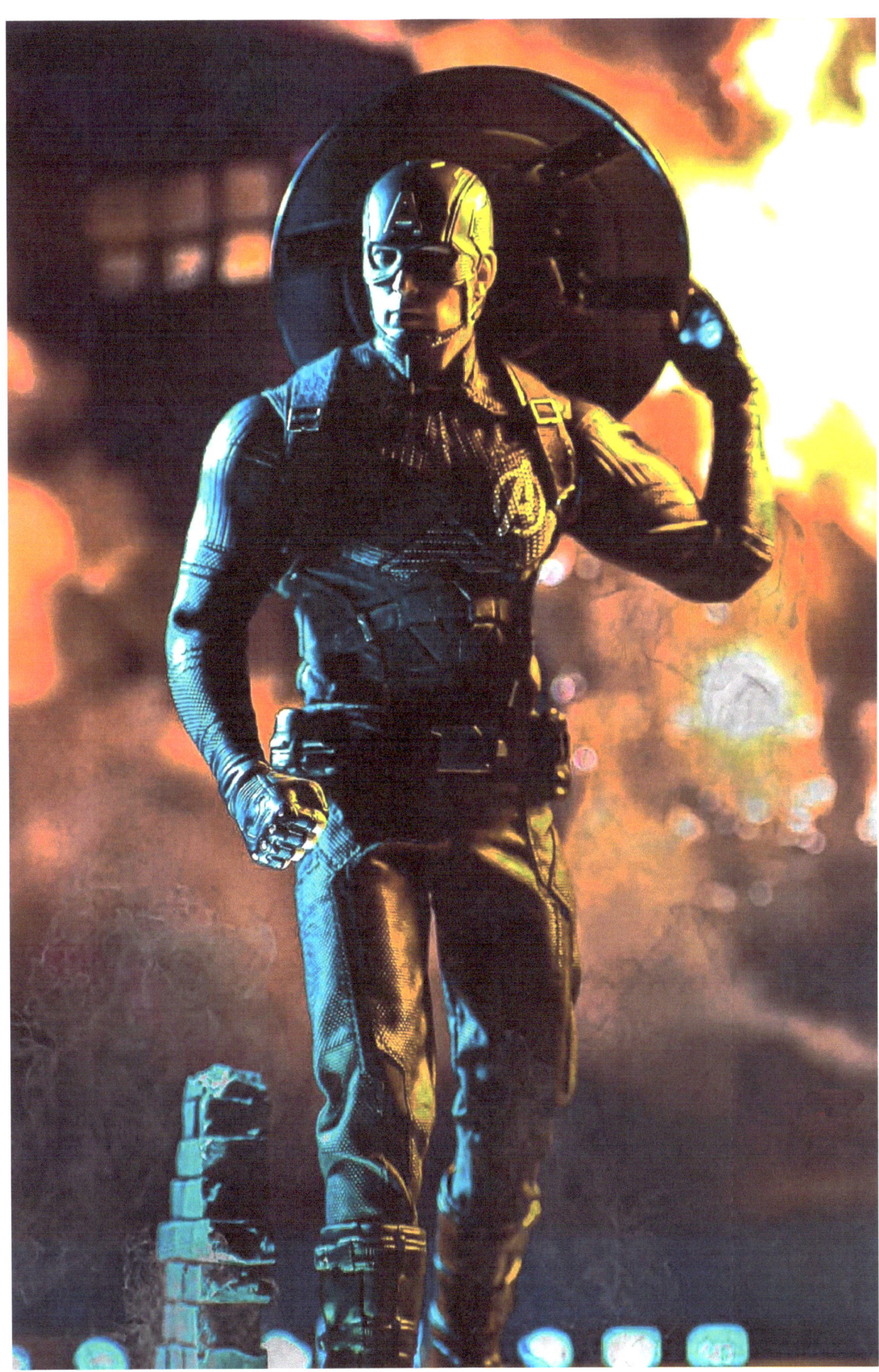

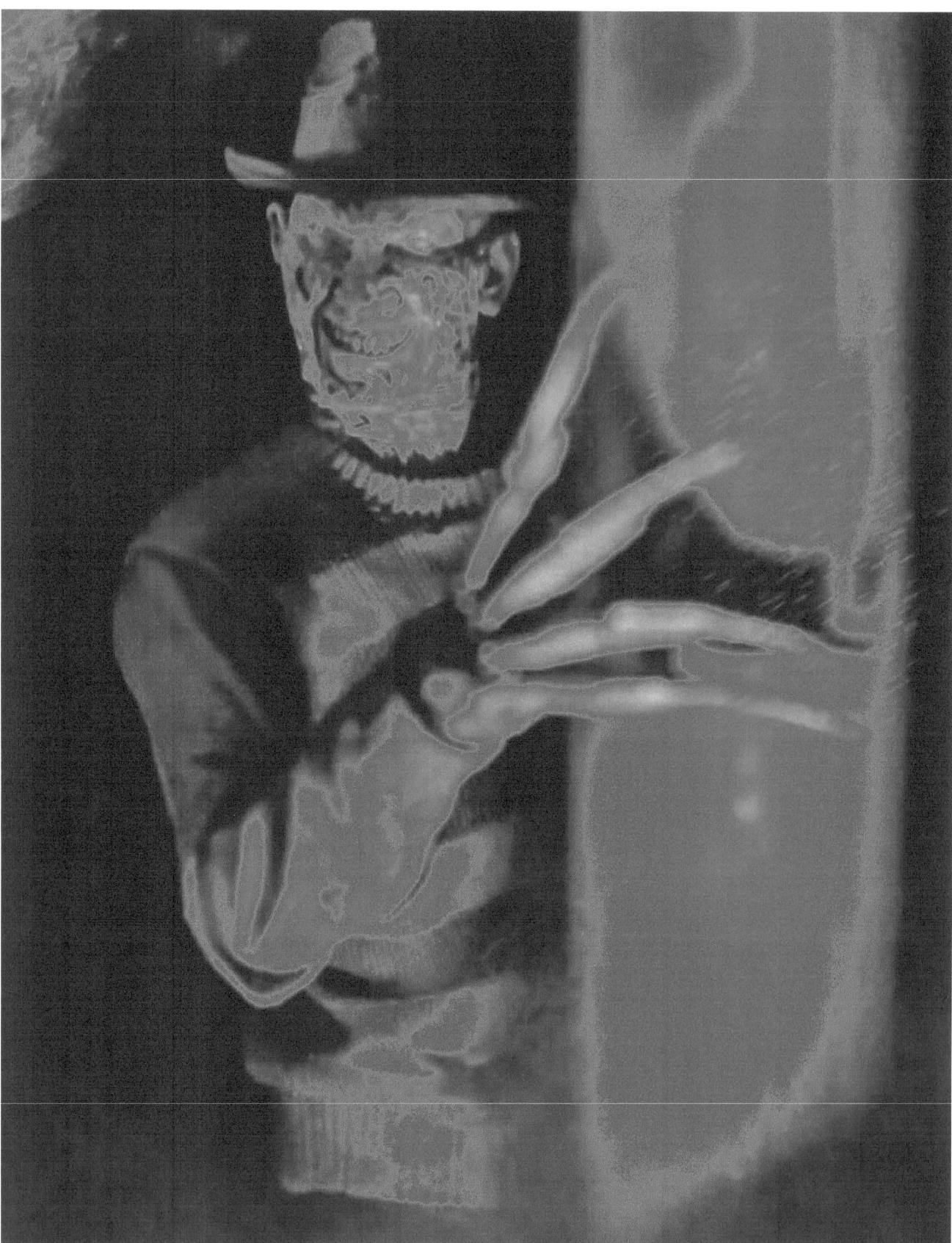

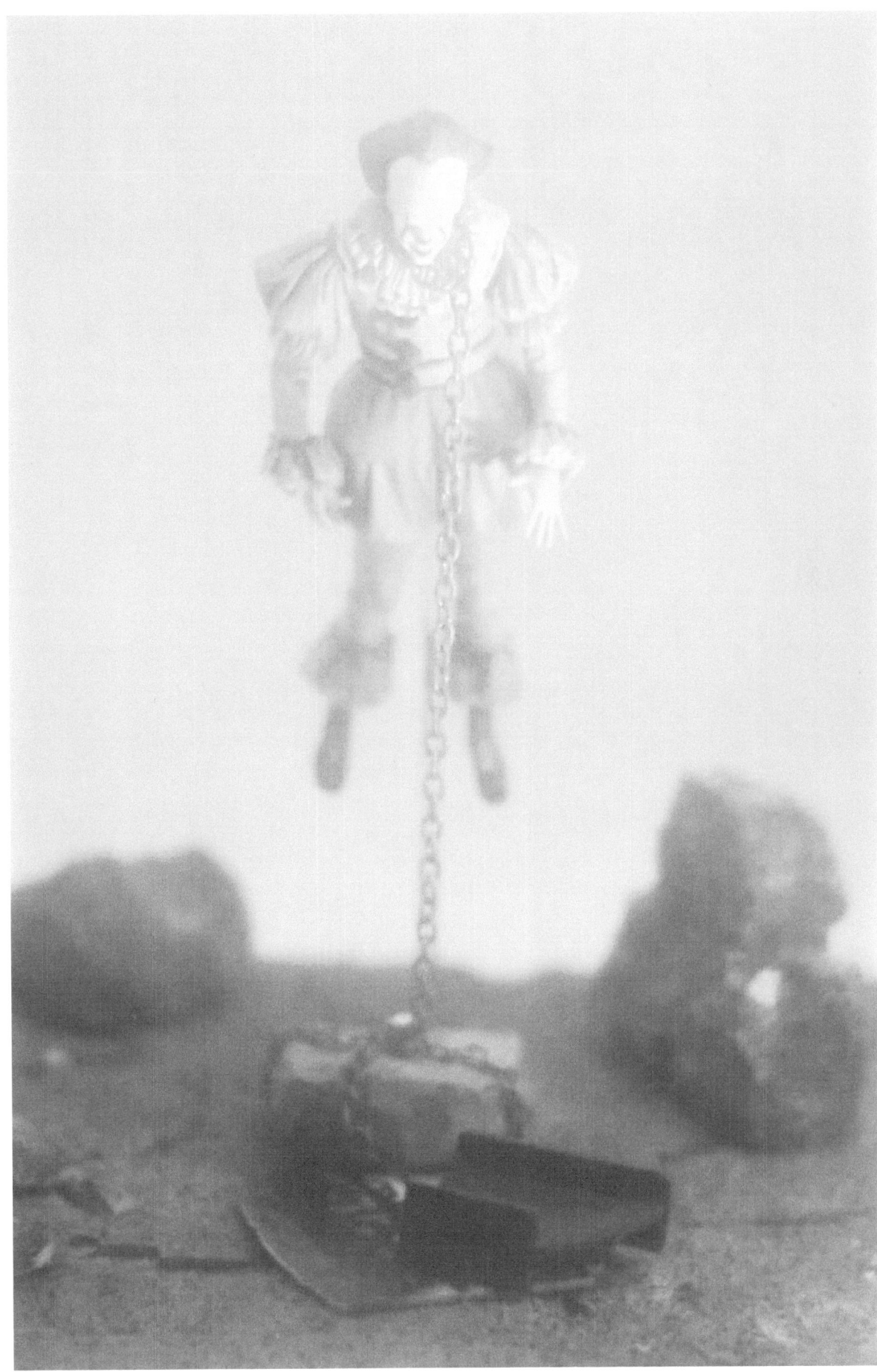

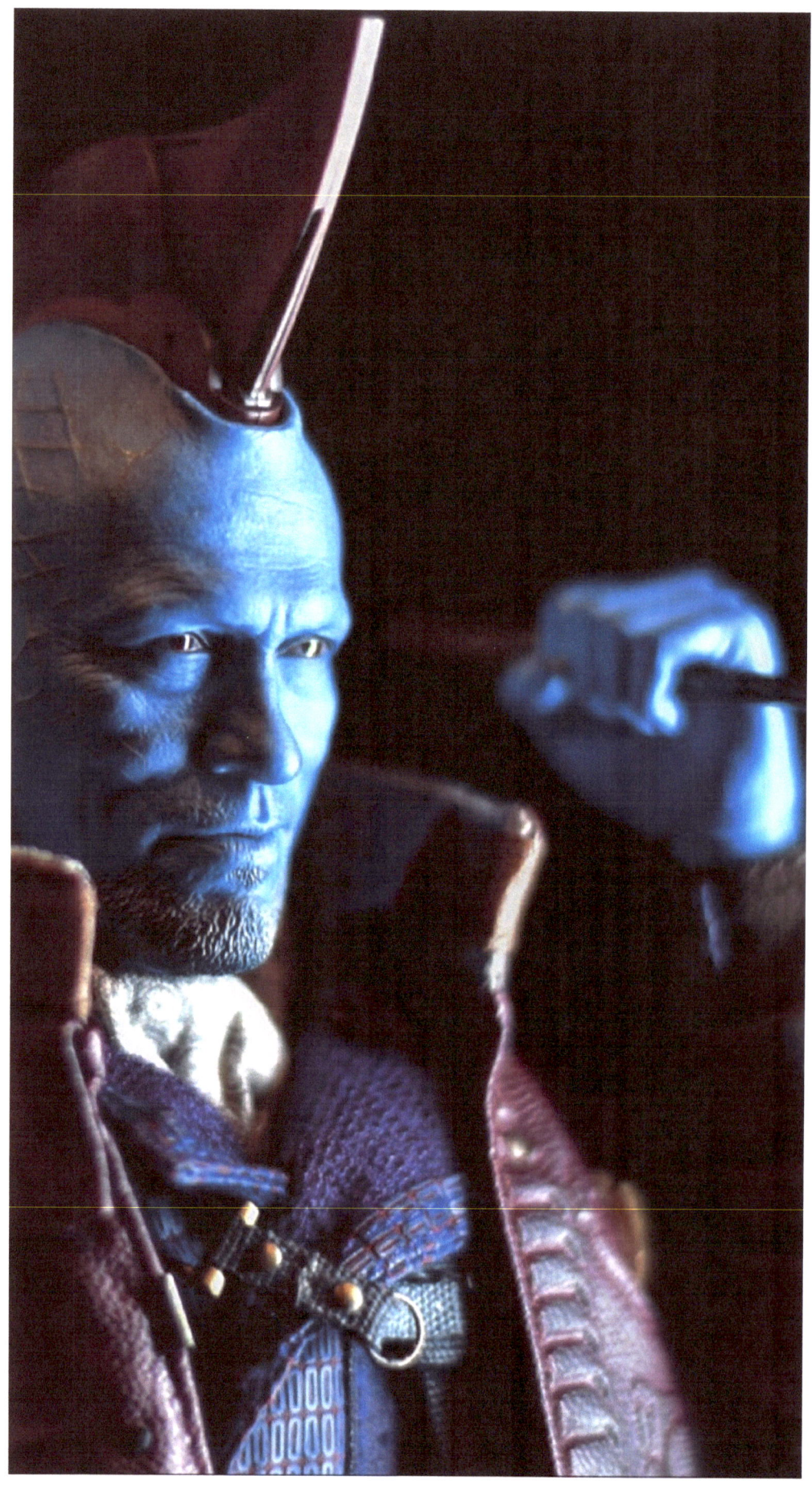

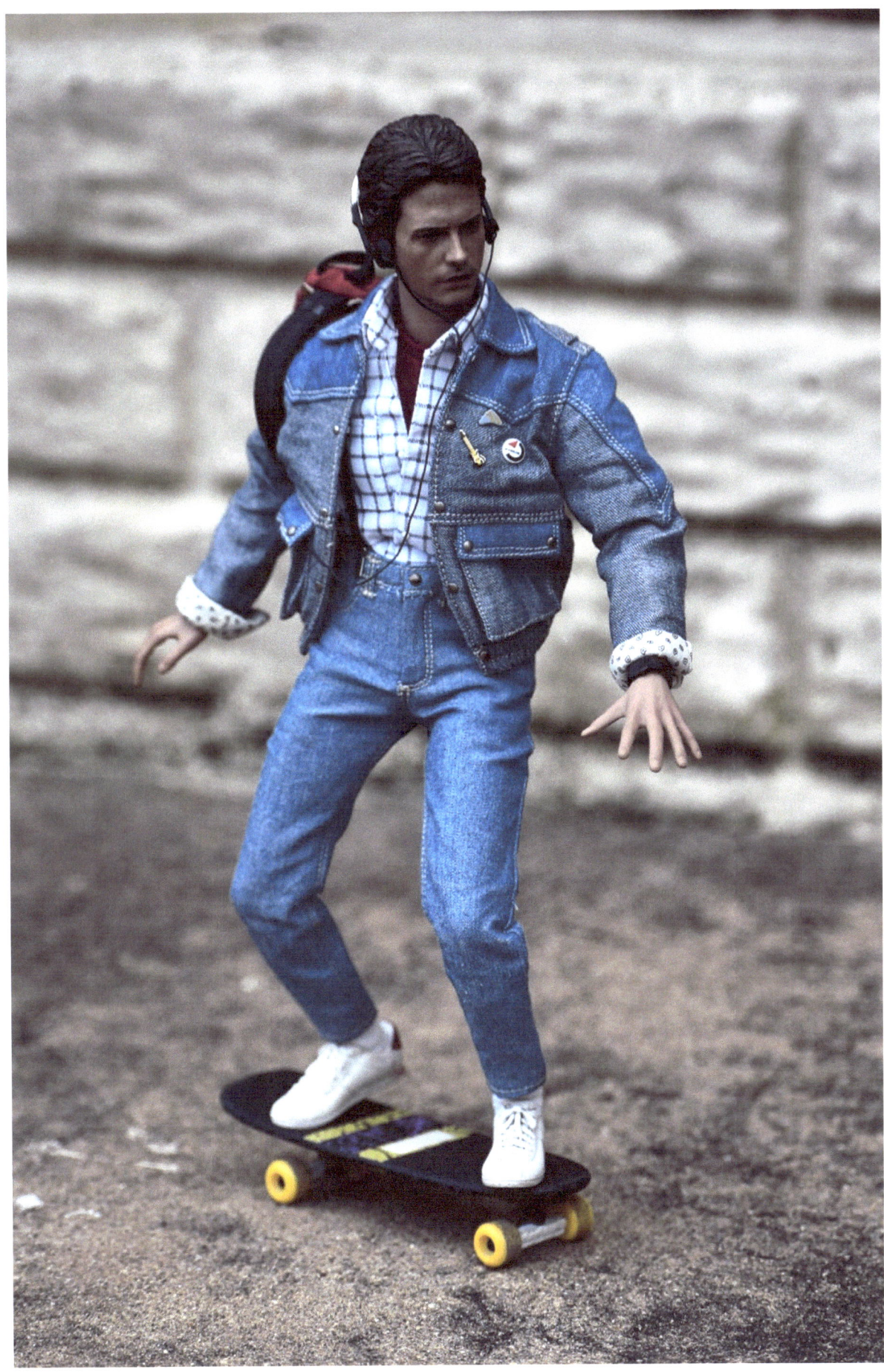

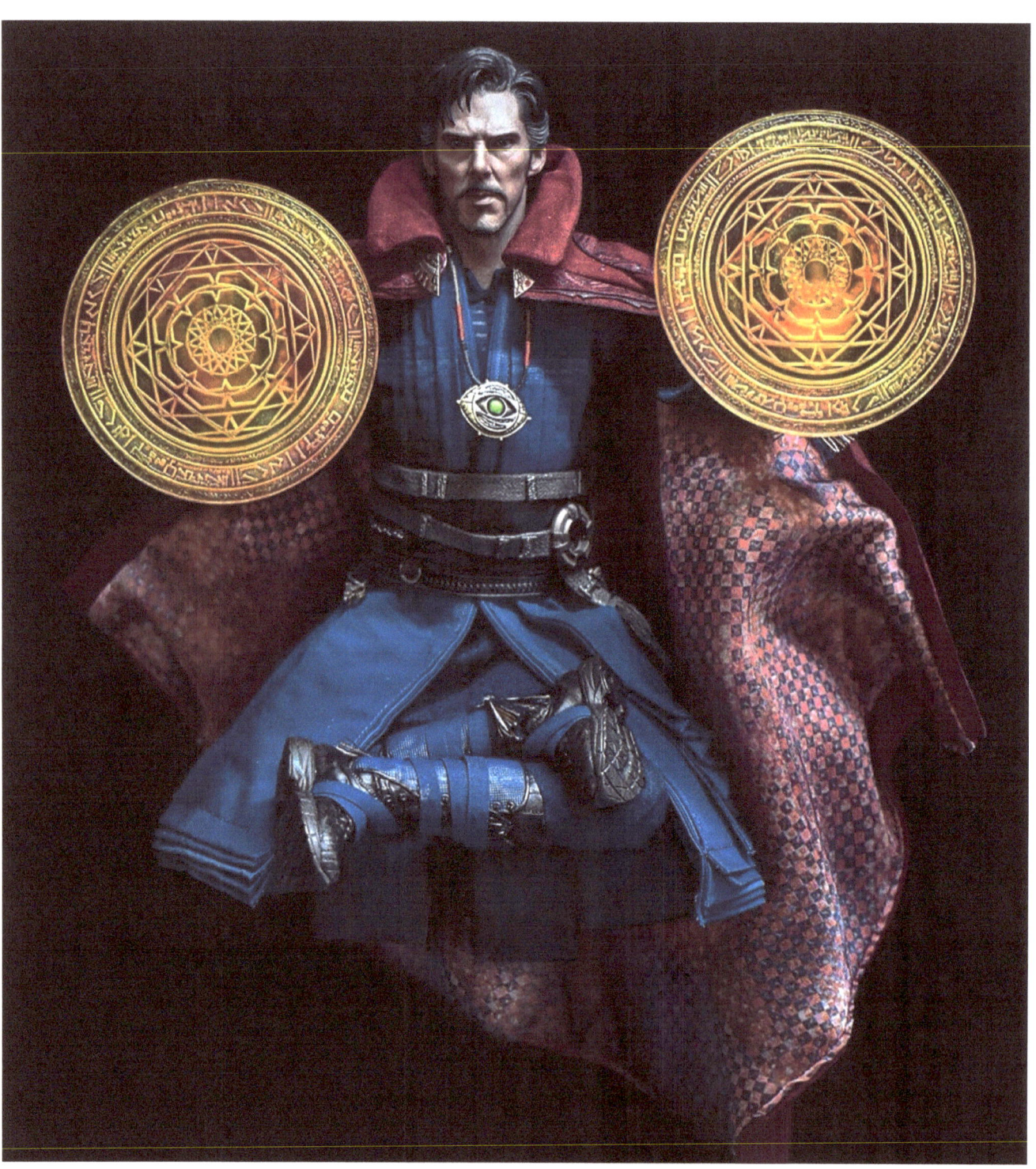

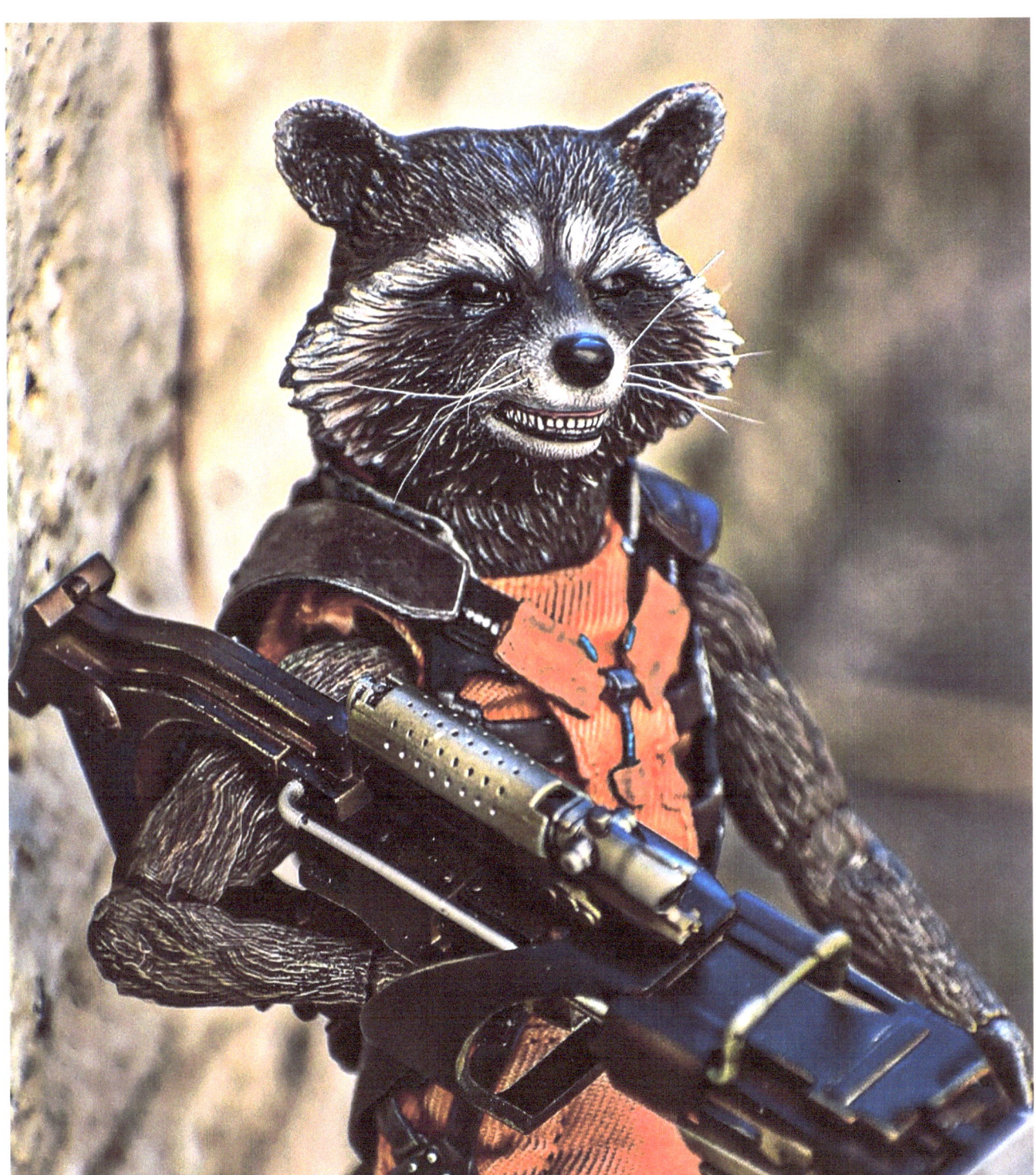

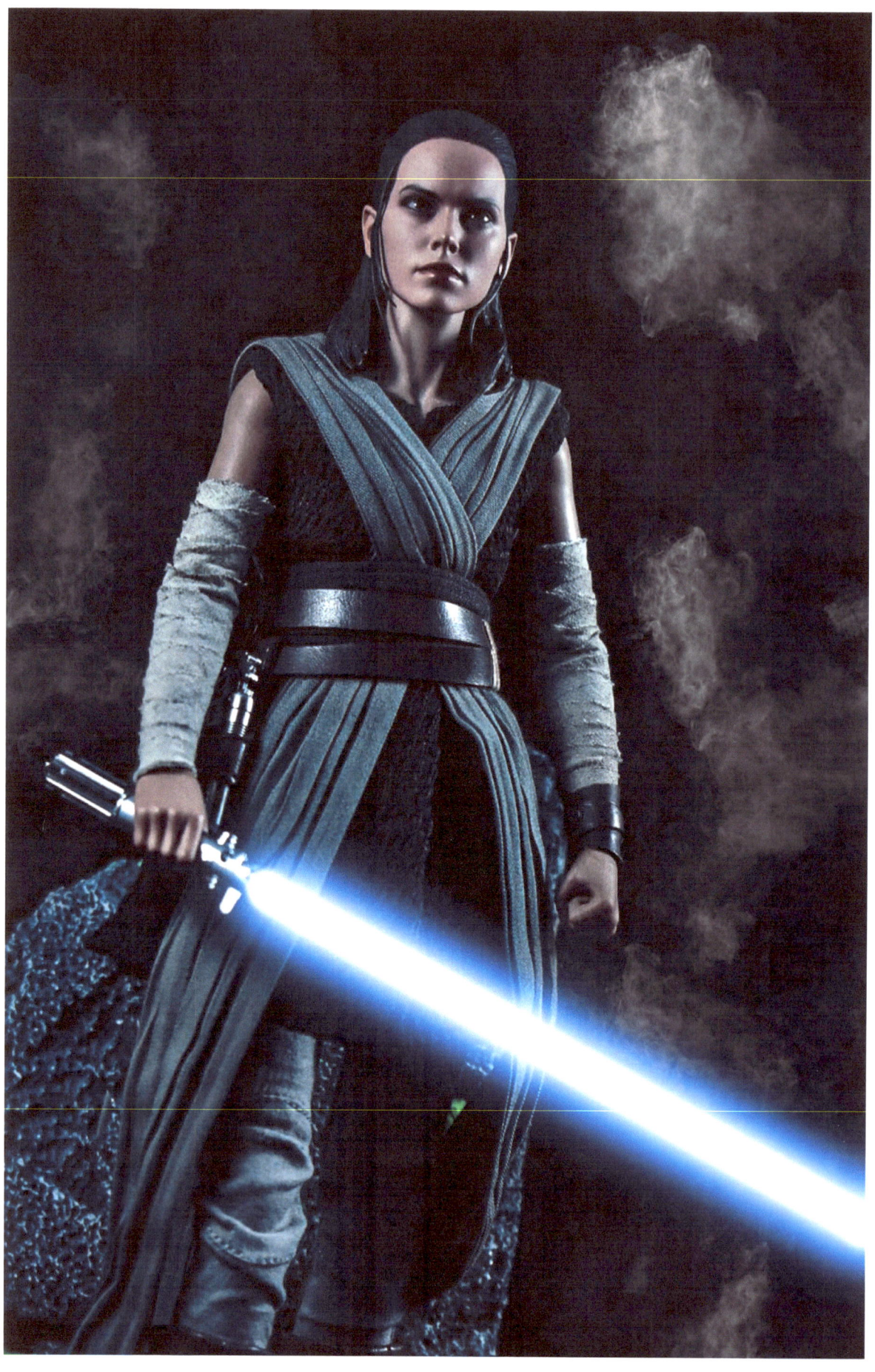

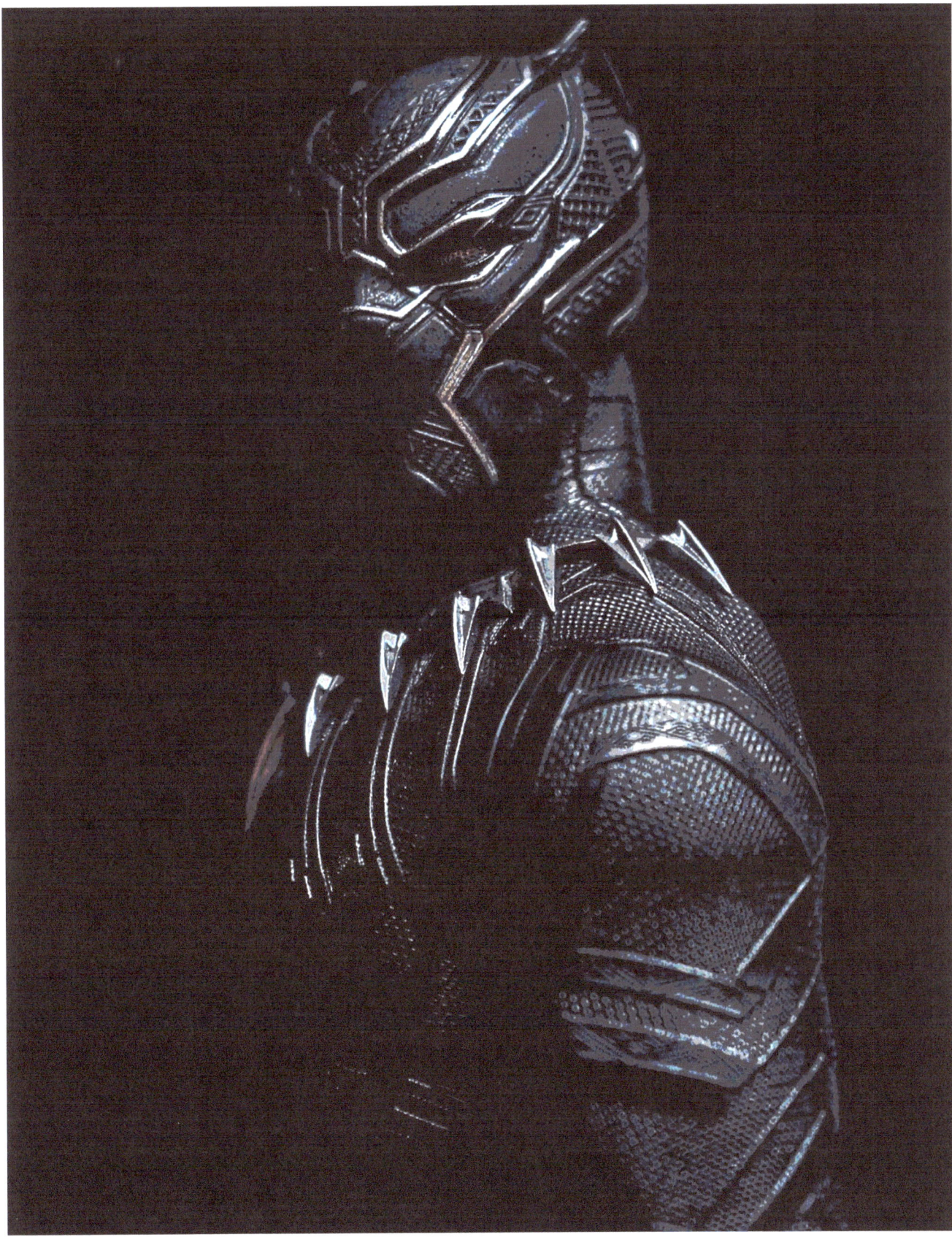

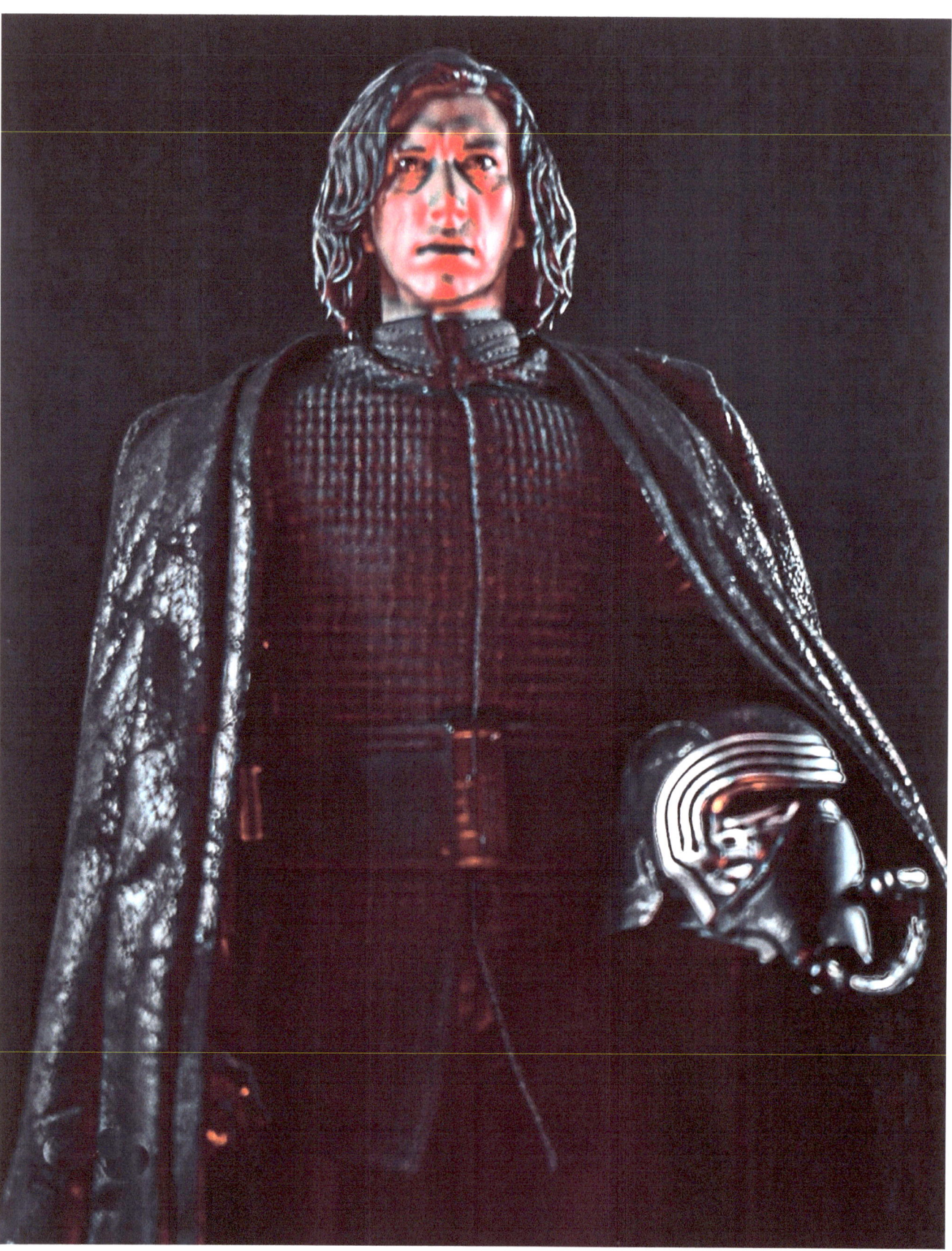

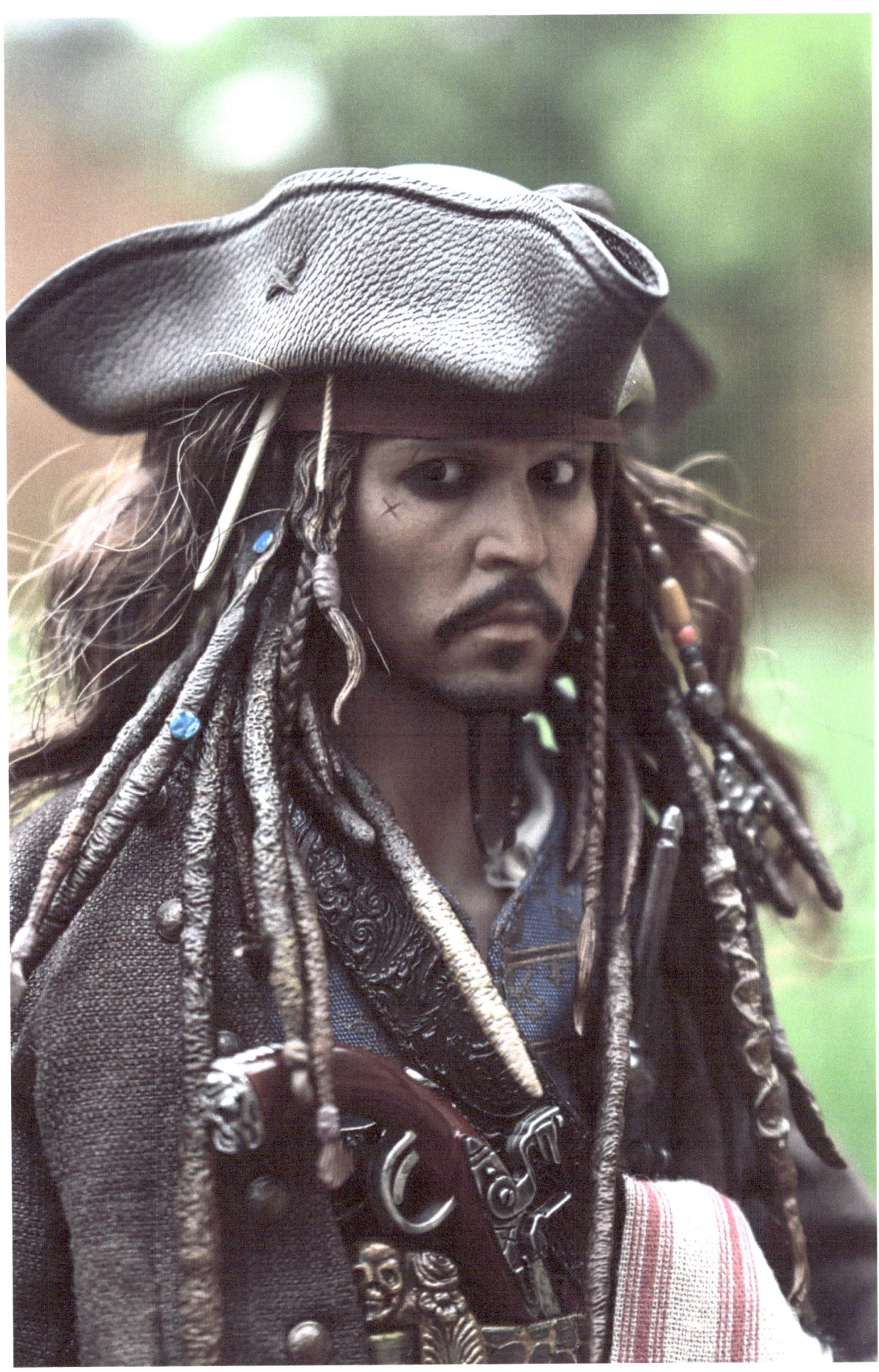

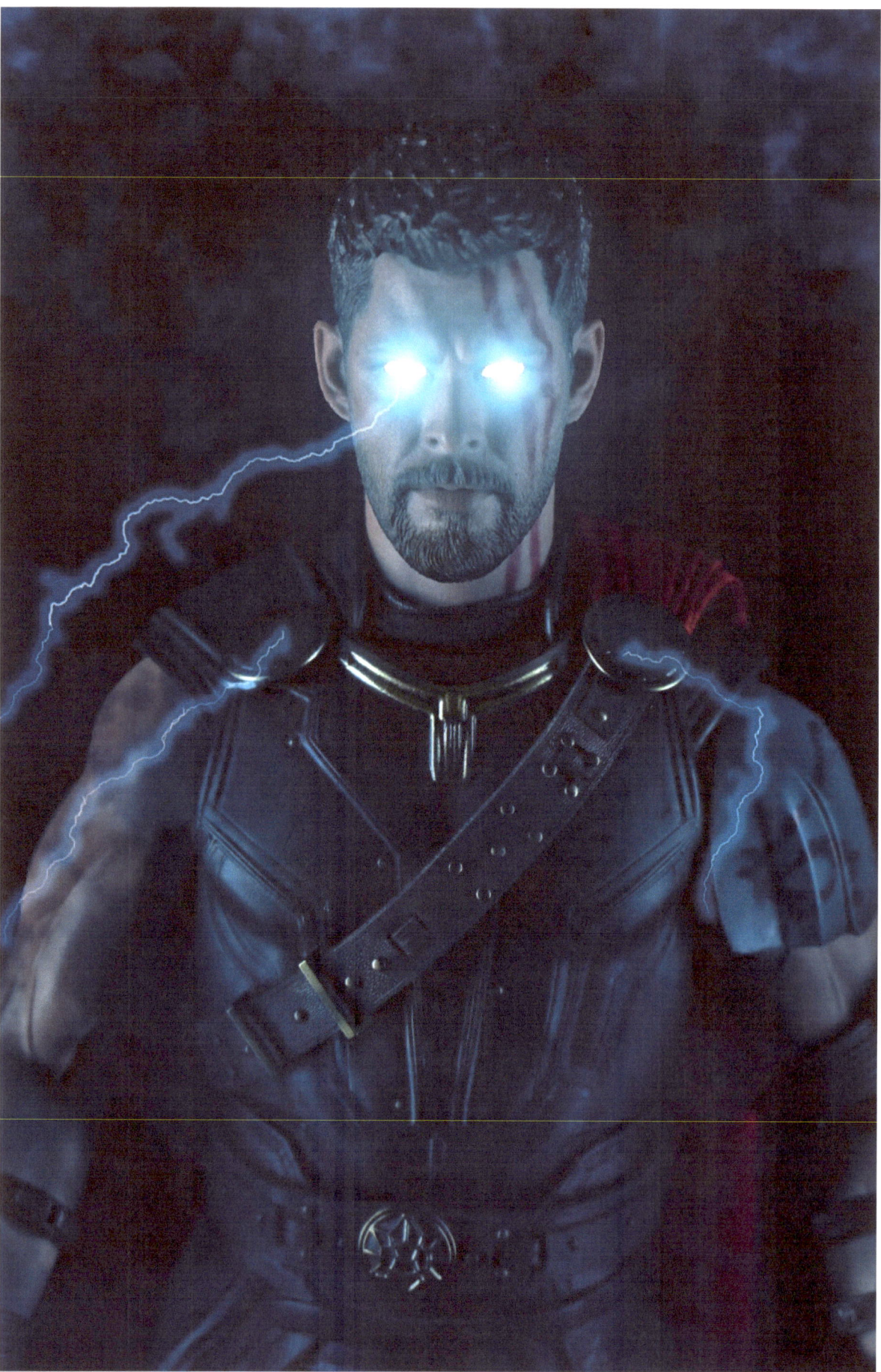

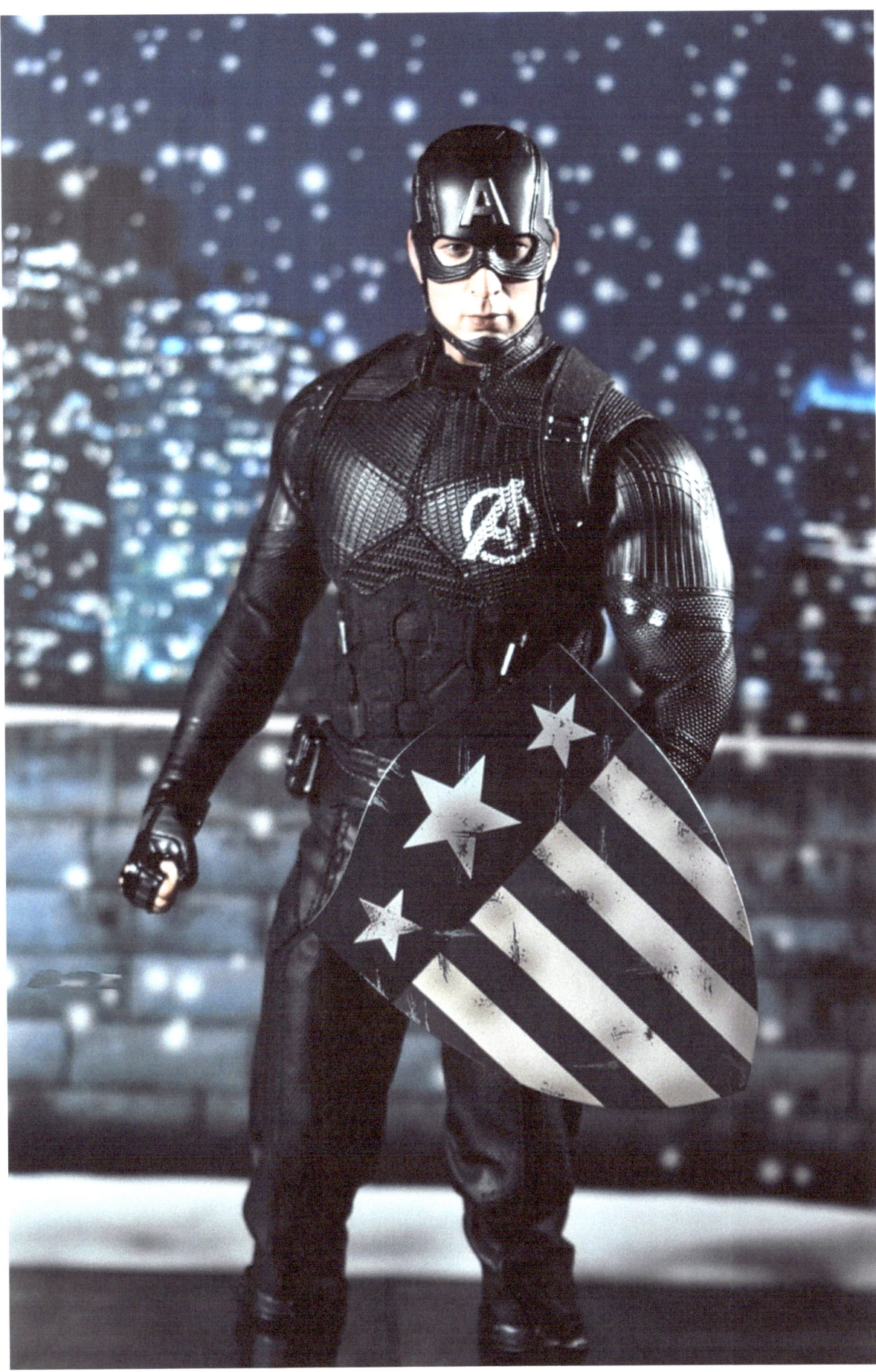

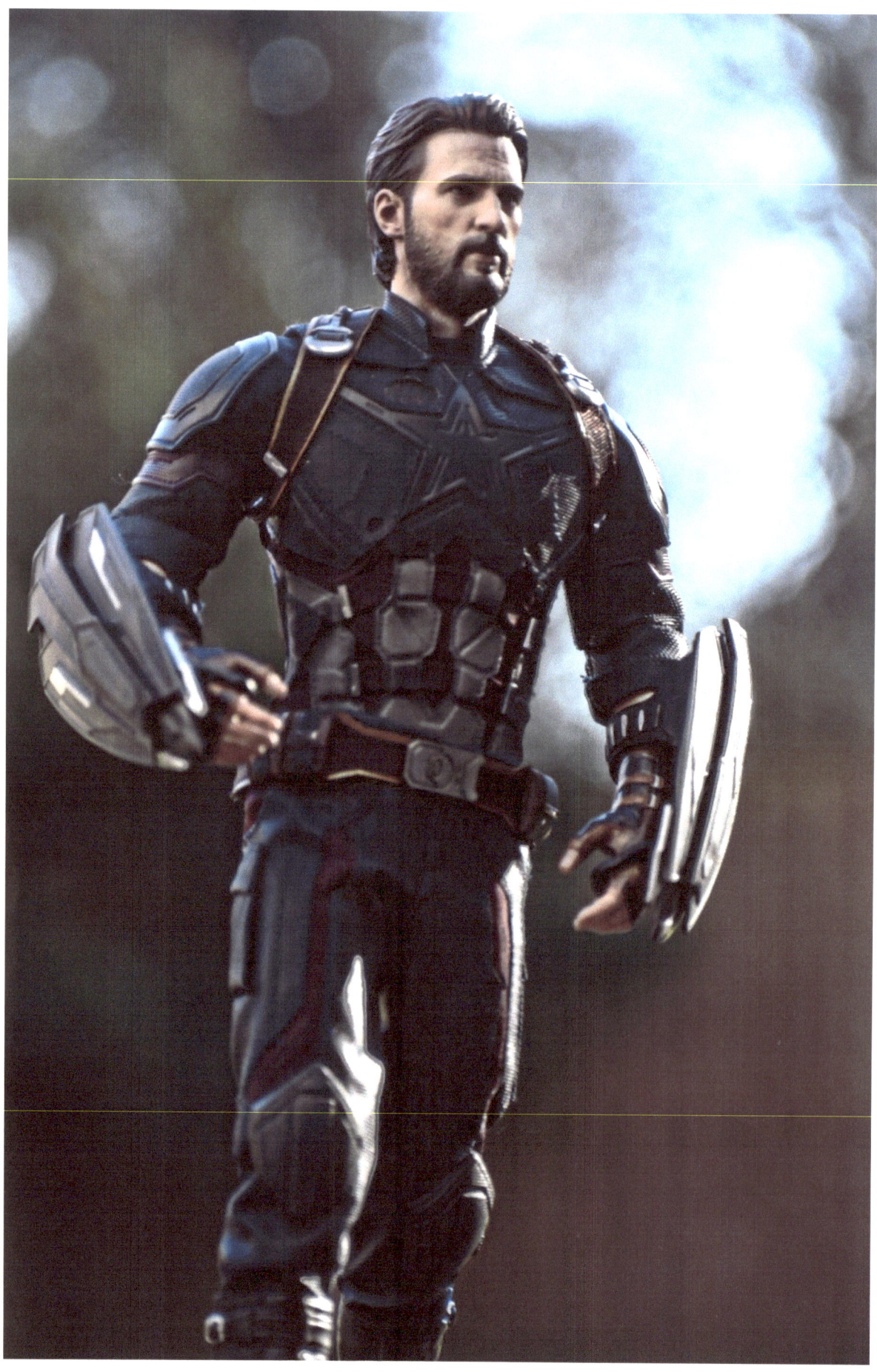

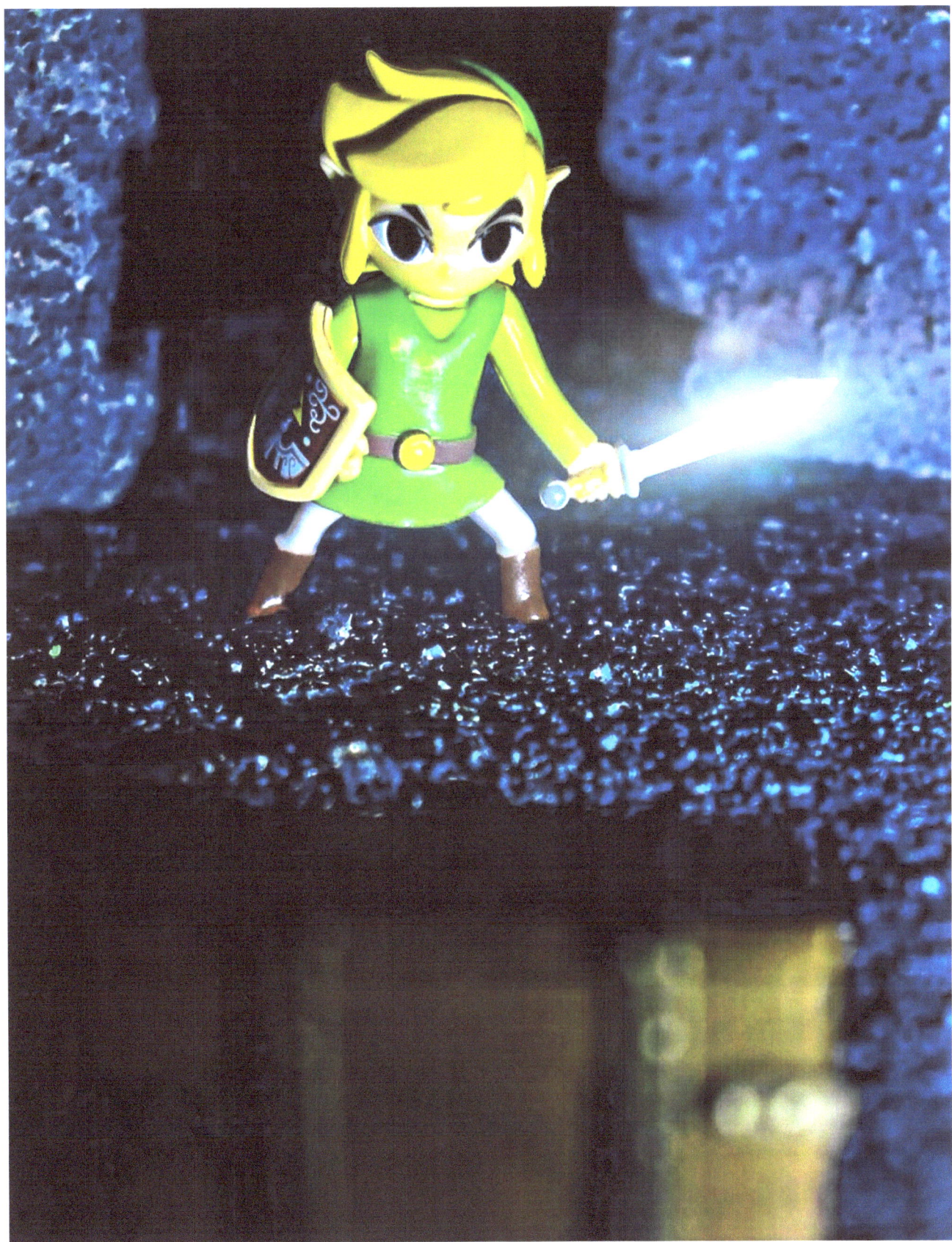

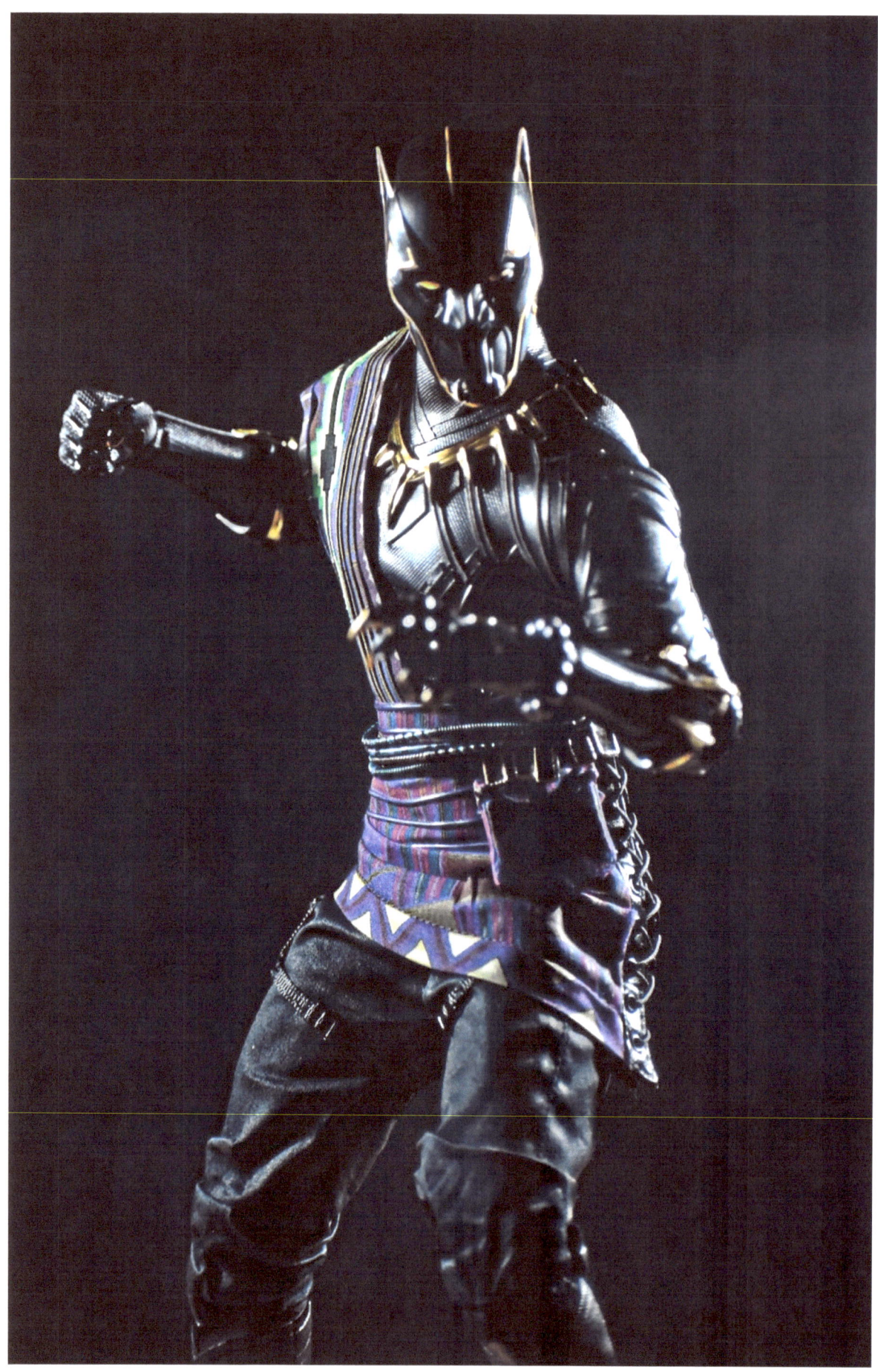

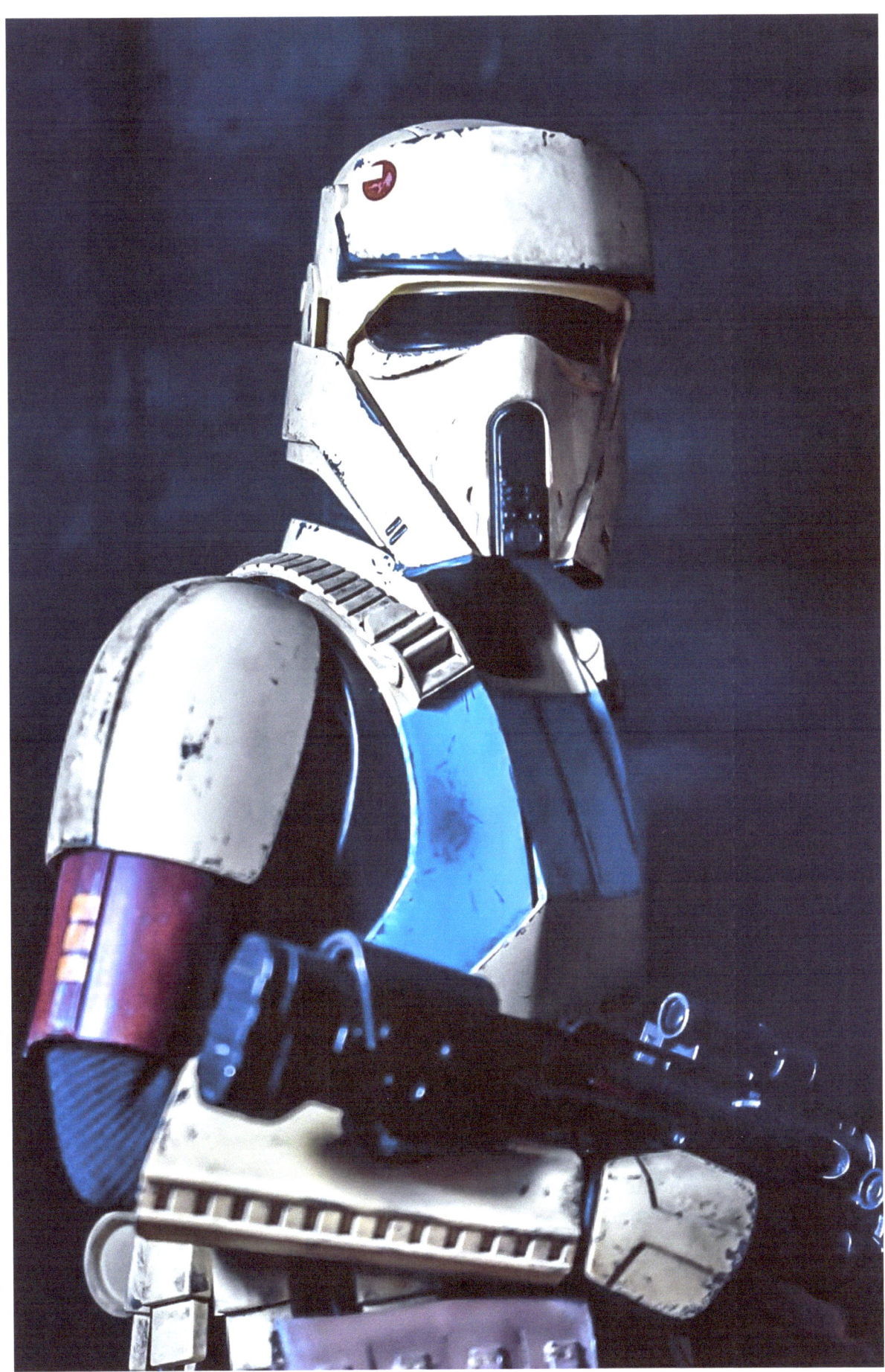

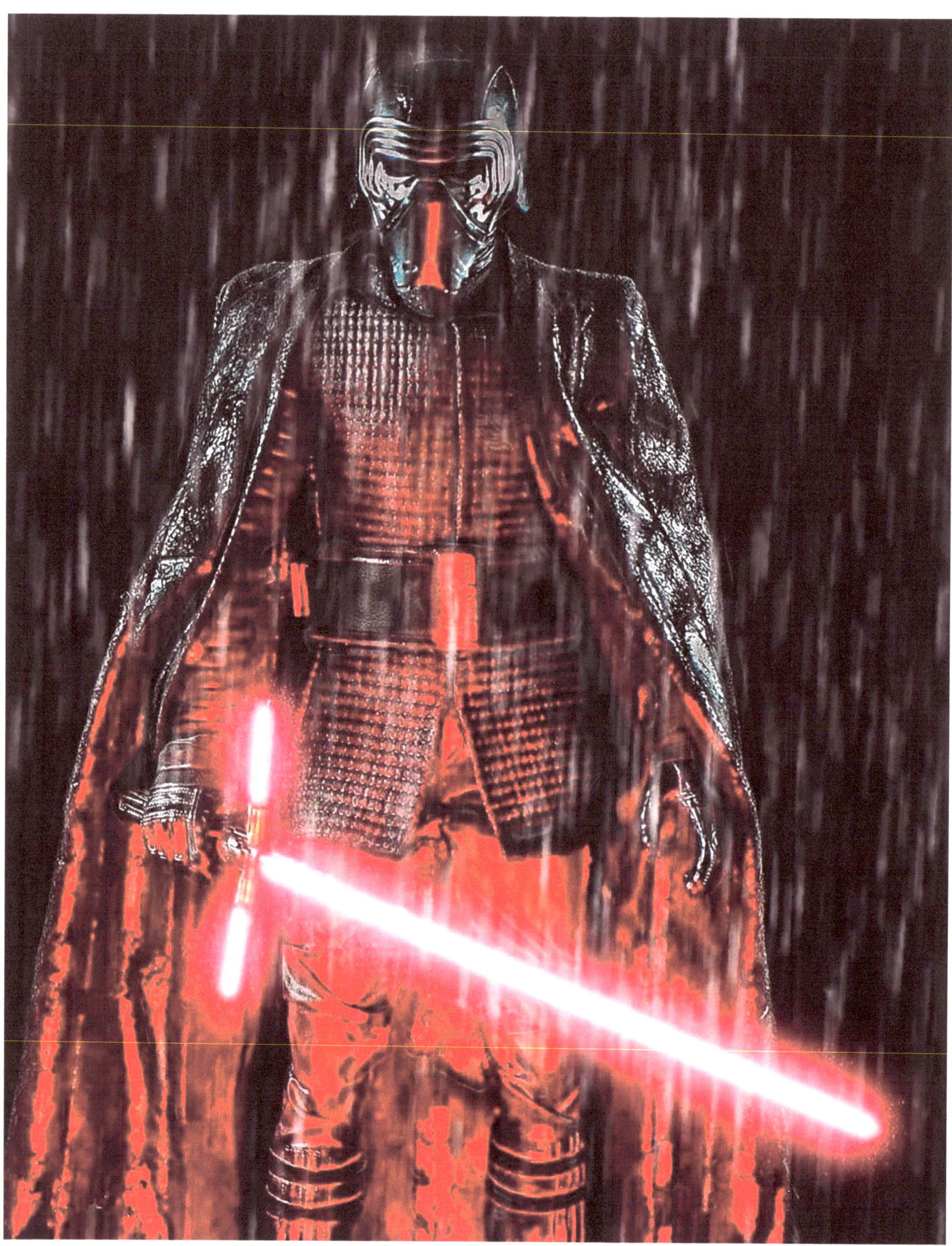

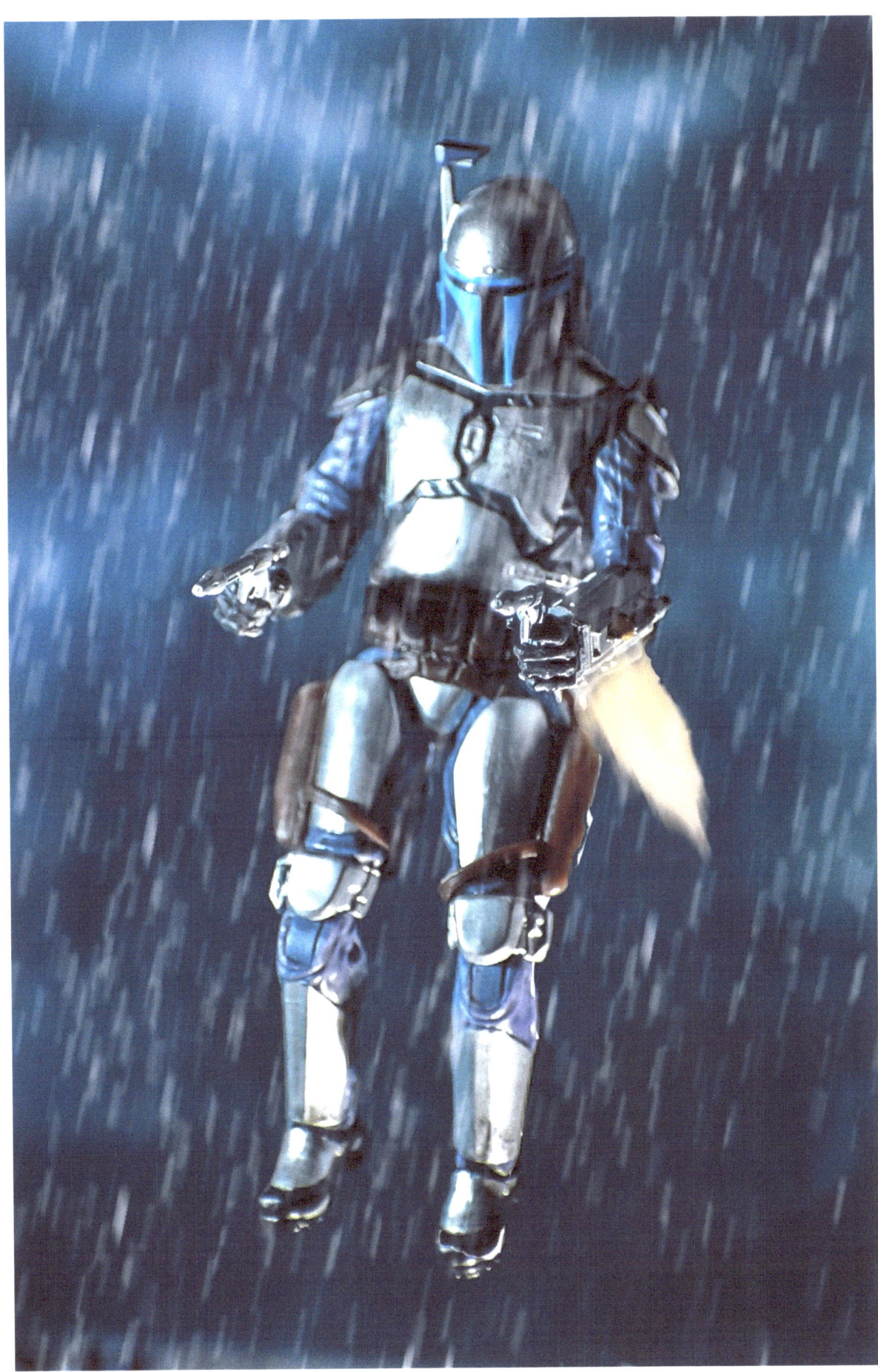

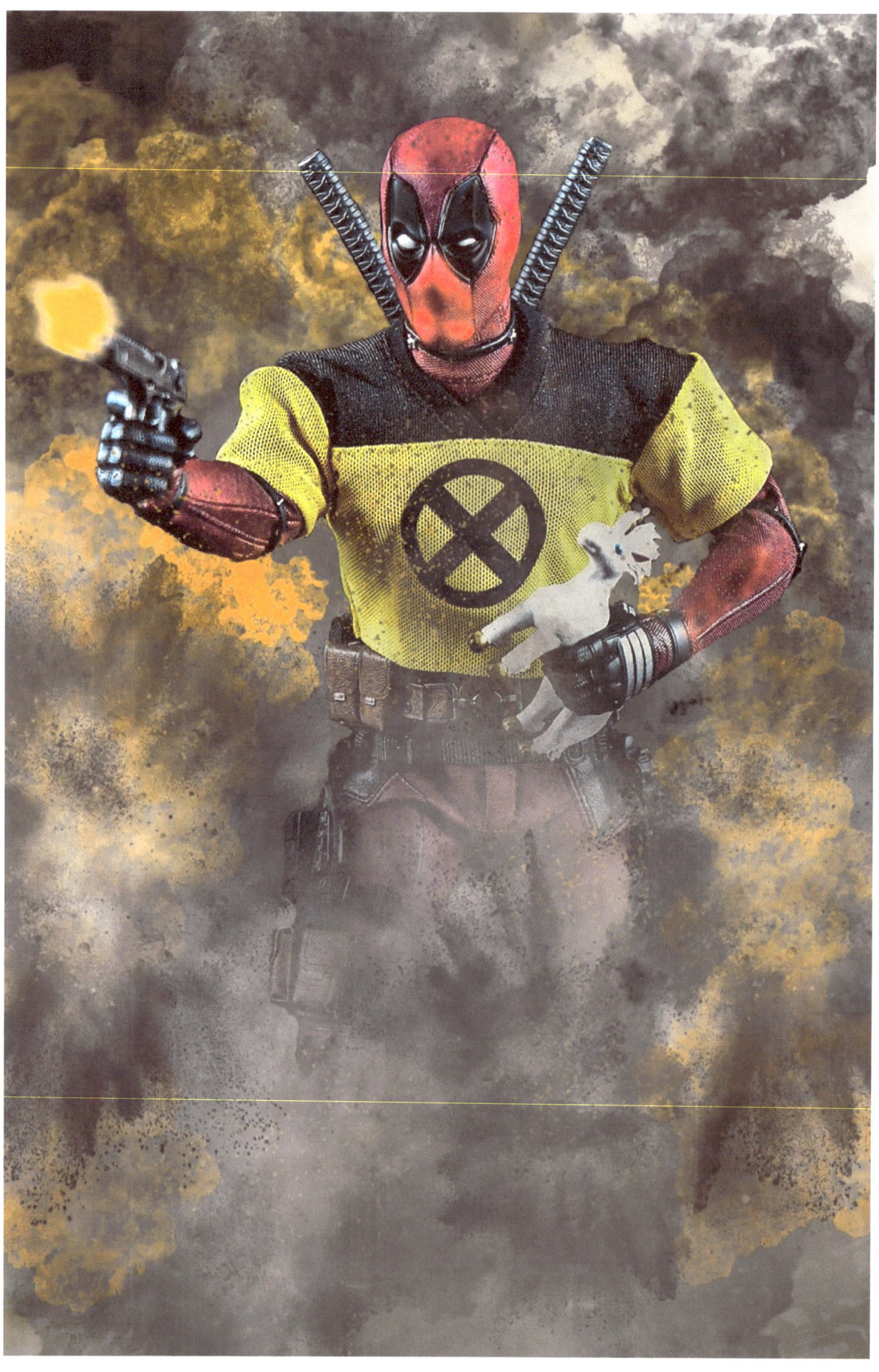

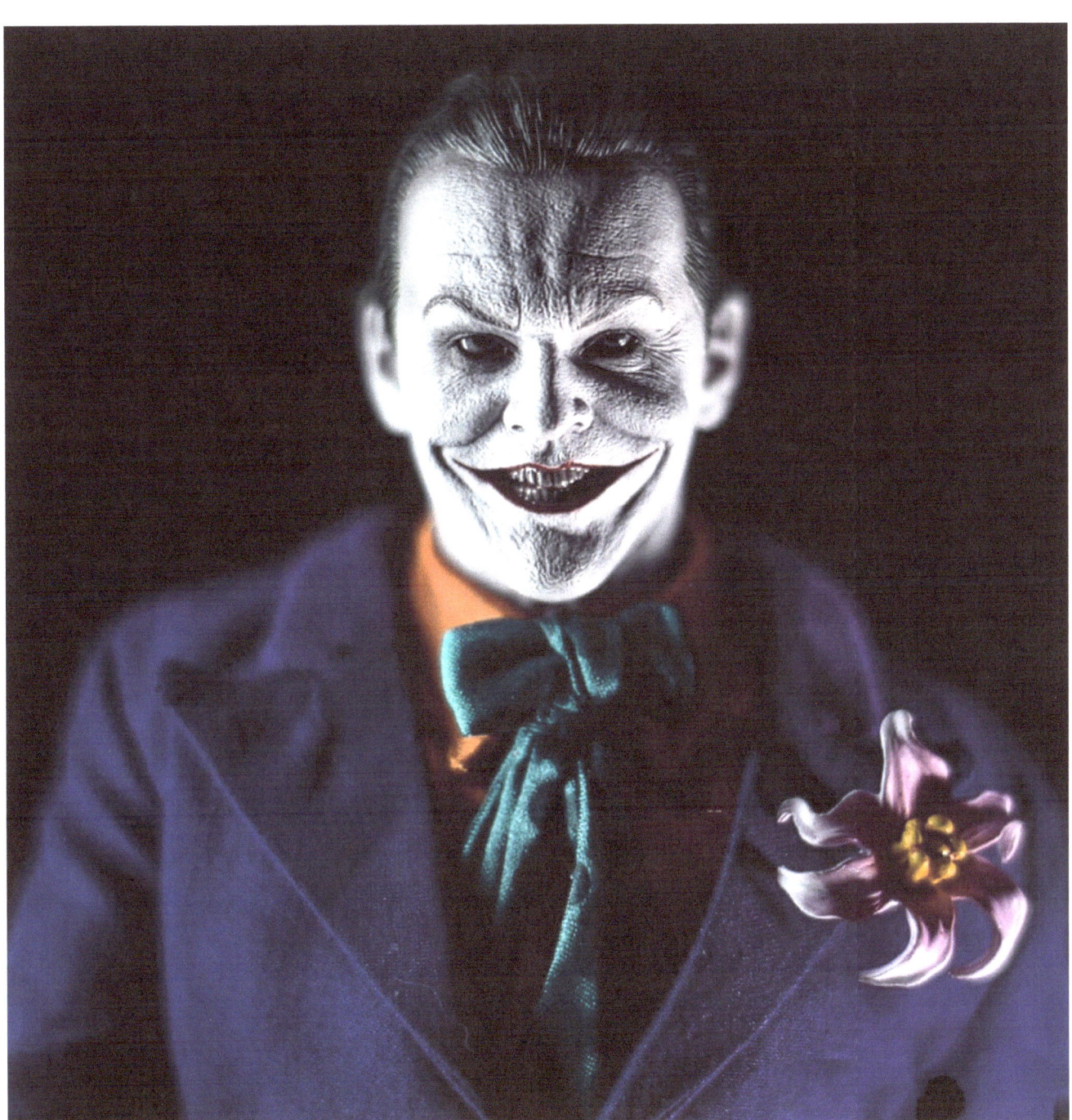

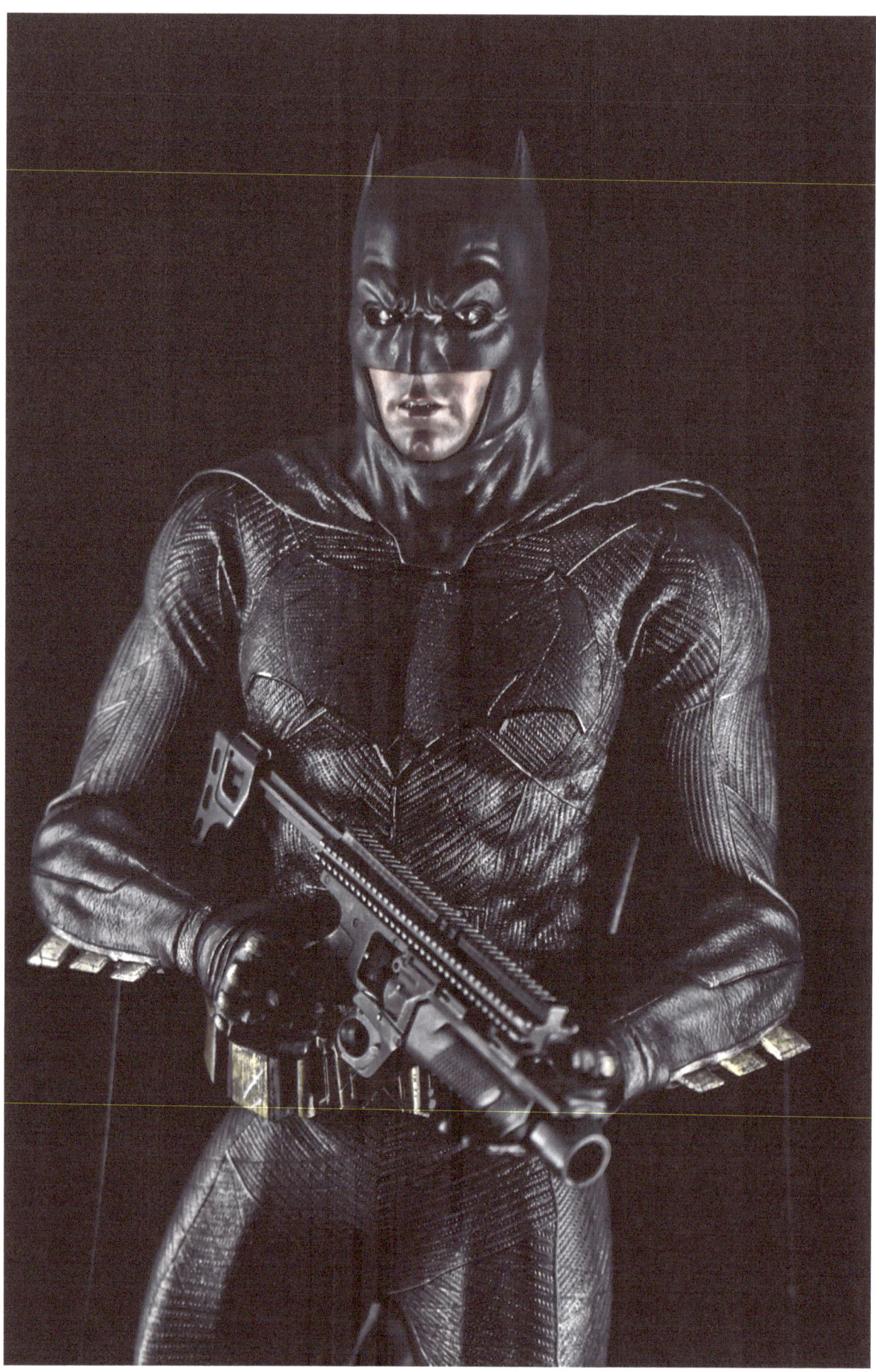

ABOUT THE AUTHOR

This is the first book published by Jeremy Guerin. He also runs an Etsy shop where he sells much of his photography and artwork as well as an Instagram page with nearly 4000 followers that showcases his work. He was born in Washington, D.C. and has lived in Northern Virginia most of his life. He's a husband and father of two young kids. They call Leesburg, Virginia home.

You can find Jeremy's Etsy shop here:

https://www.etsy.com/shop/ArticulatedArtwork

Instagram:

https://www.instagram.com/collectin_toyz

www.ingramcontent.com/pod-product-compliance
Lightning Source LLC
Chambersburg PA
CBHW041315180526
45172CB00004B/1108